IMAGES
of America

SHINNECOCK
INDIAN NATION

ON THE COVER: The 1968 Shinnecock Powwow dignitaries posed after James Allan Cameron was named an honorary member of the Shinnecock tribe. From left to right are Louis Mofsie (Green Rainbow), Hopi-Winnebago; Thomas J. Dorsey (Tom Two-Arrows), Delaware/Lenni Lenape; Henry Bess (Chief Thunder Bird), Shinnecock; Paul Horn, Caughnawaga Mohawk; John Diabo (Chief Bright Canoe), Caughnawaga Mohawk; James Allan Cameron, Southampton resident and friend of the tribe (meaning not a member of the tribe); Harry Williams (Chief War Hawk), Shinnecock; and Charles Smith (Chief Red Fox), Shinnecock. (Courtesy of the Shinnecock Nation Cultural Center and Museum.)

IMAGES
of America

SHINNECOCK
INDIAN NATION

Beverly Jensen

ARCADIA
PUBLISHING

Published by Arcadia Publishing
Charleston, South Carolina

Printed in the United States of America

Library of Congress Control Number: 2014953721

For all general information, please contact Arcadia Publishing:
Telephone 843-853-2070
Fax 843-853-0044
E-mail sales@arcadiapublishing.com
For customer service and orders:
Toll-Free 1-888-313-2665

Visit us on the Internet at www.arcadiapublishing.com

To the People of the Stony Shore, warriors of the waters, mothers of the earth, still moving through the ages—together.

Mamoweenene (We move together).

CONTENTS

ACKNOWLEDGMENTS

This book would not have been possible without the assistance of the People of the Shinnecock Indian Nation—the ones from the past, whose loving spirits continue to watch over us, and those of the present, who live across the road, up the road, down the road, on the other side of the reservation, up-street, and around the country. *Tabutne.* Thank you, one and all.

A very special thank you goes to tribal elder Shirley Smith for her enthusiastic endorsement and encouragement. Thank you to David Bunn Martine, artist, author, and curator of the Shinnecock Nation Cultural Center and Museum, who offered encouragement, shared his expertise on Shinnecock history, and opened wide the door of the Shinnecock Nation Cultural Center and Museum for research; to Eugene E. Cuffee II, who generously shared photographs and his encyclopedic knowledge of Shinnecock history in the telling of this story both through photographs and photograph captions; to photographer Richard T. Slattery, for sharing his time and photography expertise for this project; to the Reverend Michael Smith, pastor of the Shinnecock Presbyterian Church; and to Donald Williams Sr., for sharing his knowledge of the past and some very funny Indian stories. A thanks goes to the Southampton Historical Society for sharing their archival materials. And last, but certainly not least, thank you to Bob and our daughter, Lori Jensen Gomez, for being there without question. But it is our grandchildren growing up in the West who made this project so dearly personal for me: Alyssa Sunbow, Alexandria Spring Water, and Elijah Storm Star. A purpose of this book is so that you may know something of your truly wonderful and rich heritage of Shinnecock.

We are the Shinnecock, the "People of the Shore."

Tabutne (thank you), one and all.

INTRODUCTION

The Shinnecock people have been in these eastern woodlands since the last Ice Age and perhaps even as long as forever, according to a Long Island Indian creation story, surrounded by the great wealth provided by Providence. As hunter-gathers, they fished and shellfished in the freshwater and saltwater bodies in the area. With sharp arrows and strong bows, they brought down deer and other wild game for meat. They harvested roots and berries from the woods and grasses, and they built and lived in breezy shelters along the waterfront during the summer months. In the winter, they moved inland away from seaside winds. When peace came between them and the New England tribes, they took out their dugout canoes and paddled across the waters to Connecticut or Rhode Island. Once great whalers, today's Shinnecock rarely see whales, unless from a commercial vessel out on the ocean or a whale that has floated in or run aground and died from illness or injuries sustained from a mishap at sea, such as getting mangled in an ocean liner propeller.

As fate would have it, the Shinnecock, first residents of what became the town of Southampton in 1640, find themselves today in the middle of one of the most popular summer resort areas in the world, its roads in and around the Hamptons jammed with cars, trucks, and buses and its waterways filled with boats and yachts and other gas- and diesel-powered water toys from June to early fall. Pollutions brought on by human activities means that harvesting eatable shellfish from the surrounding waters can sometimes be risky. Even the venerable northern quahog hard-shelled clam, a protein source harvested by coastal peoples for thousands of years, has been known to be an unhealthy choice to eat raw in recent years. Pollution is also changing another property of that clam. Its deep purple and white inner shells form the basis of a wampum industry centered among Northeast tribes such as the Shinnecock and the Narragansett, which stretches unbroken from the pre-Colonial period to present day. In olden days, the shells were made into disks and strings of wampum were used like money for trading purposes. Today, the shells are cut and polished into "stones" for white and purplish rings, necklaces, and other forms of jewelry. But where there is pollution in the waters, there is a dearth of purple in the clam, making it more difficult to find suitable shells for the wampum jewelry trade. Whether seeking the clam for food or for its shell, harvesting today means, as one tribal fisherman put it, really knowing the water and finding the hidden pockets where there are little pollutants.

In the 1970s, the tribe applied for federal recognition and more than 30 years later, in October 2010, achieved a government-to-government relationship with the United States of America. Most Shinnecock thought they already had that since a government-to-government relationship with the State of New York had been established in 1792, when the three-person (male) trustee system of tribal government went into effect. During the pre-federal recognition period, the tribe also voted to allow women to vote, established a 13-member tribal council as an advisory board to the trustees, and acquired the symbols of a sovereign nation—a flag and a seal. Then came more change. The tribe adopted its first constitution in February 2013 and changed its governmental leadership from a three-member board of trustees to a seven-member Council of

Trustees and disbanded the tribal council. The first election under the constitution took place in December 2013 and brought two women into the office of Council of Trustees. This election was also significant because it changed the length of a trustee term from one year to two years and included the election of two elders, one male and one female, to serve in traditional roles as a sachem and a sunksqua.

The People of the Shore are a part of the big family of Algonquian native people stretching from the Carolinas to the Great Lakes. If there was ever a time when they were not self-governing, the Shinnecocks seem not to want to know about it. As their flag proudly proclaims, they are Algonquian and "Always Sovereign." If there was a period or two in history when the People of the Shore fell under the dominion of any other tribe, that would have been just a bump in the road—a short-lived anomaly. To the Shinnecock, "Always Sovereign" not only means standing firm and tall as Shinnecock but also means always holding on to the land, not losing one more inch to encroachers. Throughout the decades, Shinnecock have maintained close watch over their remaining territory. One story told during the research phase for this project was how, when a flagpole was erected in front of the old Shinnecock School in the early 1900s, men from the tribe showed up ready for war because they thought the flagpole people were really coming to take the land. That protective attitude still exists today.

From time immemorial, the women of Shinnecock have provided rock solid, protective strength to their community as well as keeping the home fires burning when their men went off to hunt or to sea. Throughout the ages, they have celebrated triumphs and led the tribe in mourning unbearable losses, as when in December 1876 the freighter *Circassian* sank in an icy storm off Bridgehampton, taking the lives of nine Shinnecock and one Montauk Indian man. Sons, fathers, brothers, uncles, and cousins drowned at sea. For all their leadership roles at home and in the community, the women of Shinnecock had no voice in tribal elections until they fought for and gained the right to vote in the mid-1990s. Today, not only do Shinnecock women still serve powerful and protective roles in the community as mothers and teachers and in law, journalism, and medicine, they are now elected to serve as trustees.

Shinnecock people, as a whole, are proud to demonstrate their culture year-round and gather to do so as they have done since the dawn of time. In the summer, elders and babies alike, riding on floats, have participated for decades with other tribal members in the Southampton Village Fourth of July Parade, often winning prizes. In late summer, the tribe hosts once of the largest Native American gatherings on the East Coast, the annual Shinnecock Powwow. Powwow is a happy time of feasting on traditional foods, dancing, and reacquainting with old friends. It is also a time for buying and selling traditional crafts. Fall is the time for giving thanks, and the Shinnecock community does so twice, gathering to celebrate a tribal thanksgiving, also called Nunnowa, a week before the national Thanksgiving and then celebrating national Thanksgiving Day with the rest of the American country. A midwinter gathering helps stave off winter blahs, and at least one traditional dish of beans and corn is served up hot to drummers and dancers from the community and other tribal nations. Recently, Shinnecock has been a presence in the Hampton Bays St. Patrick's Day Parade in March. In the spring, the Shinnecock community has the opportunity to gather for the Shinnecock Nation Cultural Center and Museum's annual strawberry festival, as well as the Shinnecock Presbyterian Church's ancient Shinnecock homecoming celebration the first Sunday in June, called June Meeting. Strawberry shortcake is among the foods served at the church and the museum for these festivities during the spring season.

These pages offer a few vintage and contemporary glimpses of the Shinnecock, the People of the Shore—Algonquian, "Always Sovereign," and a close-knit nation of family.

One

PEOPLE OF THE SHORE

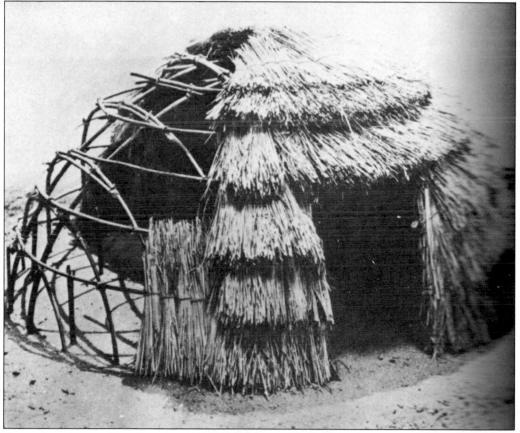

Shown here is a small replica of a traditional Shinnecock dwelling that was built by a Shinnecock tribal member sometime between 1890 and 1900. Up through the 1840s, some Shinnecock still used these dwellings as well as timber-framed houses. This photograph is one of only two known historic visual records of a traditional Native American, pre-European-style home on Long Island. (Courtesy of the Shinnecock Nation Cultural Center and Museum.)

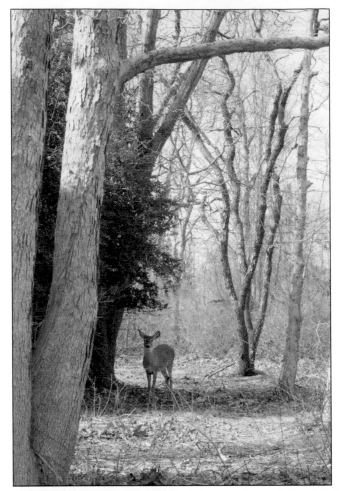

Deer was important to people of tradition. In addition to being a mythical symbol in some creation stories, deer has and continues to be a source of food. The meat can be cooked in a variety of ways, and deer dishes often show up on dining tables during winter months. One Shinnecock recently perfected a recipe for deer chili. Deer hide is used for male and female articles of clothing as well as moccasins and boots. In fact, every part of the deer is useful. (Photograph by Beverly Jensen.)

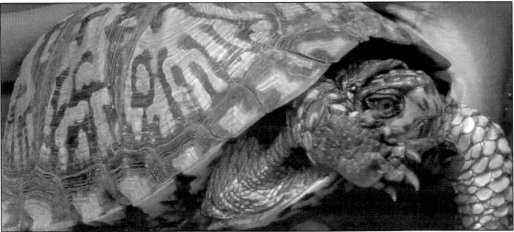

The turtle is also a mythical symbol appearing in many Native American myths and creation stories. In many, the turtle represents the Earth Mother. Some believe that there were 13 tribes on Long Island and that the 13 markings on box turtle's back represent those tribes. (Photograph by Beverly Jensen.)

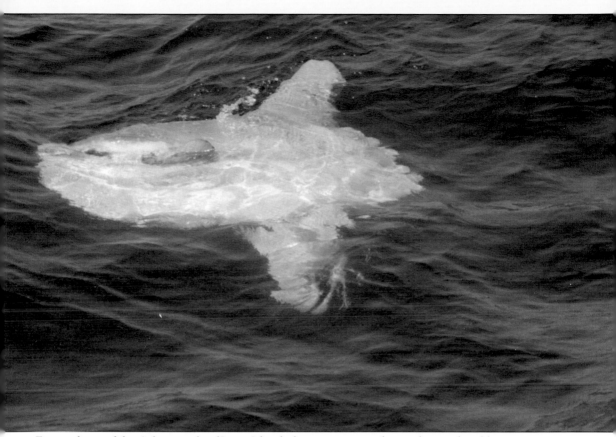

For residents of the Atlantic side of Long Island, the ocean is a mighty and unpredictable presence, with gentle waves tumbling in or thunderous waves crashing to shore loudly broadcasting its mood. Ancient Shinnecock, who sought whales and other denizens of the deep from their dugout canoes, knew when to relocate to higher ground, moving away from oceanic tides and thrashing ocean winds. Pictured here is an Atlantic Ocean sunfish, photographed by the author off Montauk Point in the summer of 2014. (Photograph by Beverly Jensen.)

Originally crafted as strings of one-quarter-inch-wide cylindrical beads for making belts, wampum has become a defining cultural icon for Long Island and southern New England tribes. One reason is because the basic raw material—the hard shell of the northern quahog clam—has been so readily available throughout history in the saltwater bays and ponds between Cape Cod and Long Island. In Colonial times, strings of wampum were used as currency to seal deals. Today, along with eastern coastal tribes, native artisans from across the country have found favor with the thick shell and have joined the eastern brethren in creating rich purplish and white rings, earrings, necklaces, bracelets, and any number of jewelry items. These shells were polished by wampum artist Herman "Chuck" Quinn (Shinnecock). (Photograph by Beverly Jensen.)

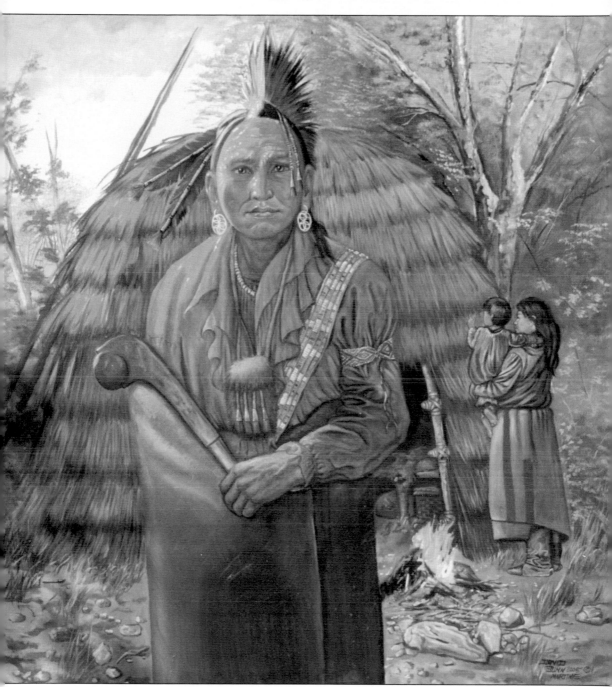

Painted by Shinnecock artist David Bunn Martine, this is a full-color oil portrait of a Shinnecock Indian at his campsite with wife and child at twilight in early fall. He is dressed in typical Native American clothing of the Algonquian woodlands culture of Long Island during the early years of European contact in the late 17th and 18th centuries. The clothing includes a wampum belt. Shinnecock craftspeople were noted throughout the Northeast and beyond for manufacturing wampum beads of superior quality. His traditional home, seen in the background, is made of thatched meadow grass. (Photograph by Richard T. Slattery; courtesy of David Bunn Martine.)

Seen here is the official seal of the Shinnecock Indian Nation. The gold flag of the Shinnecock carries the tribe's official seal, which was designed by Shinnecock artist David Bunn Martine and approved by the nation. The seal depicts the history of the Shinnecock, the People of the Shore. It includes a wampum belt; four wickiups (houses) representing early Shinnecock families; three prehistoric symbols of the Shinnecock—thunderbird, deer, and turtle; two right whales representing the tribe's whaling history; and a rising sun, promising a bright future. (Courtesy of the Shinnecock Indian Nation.)

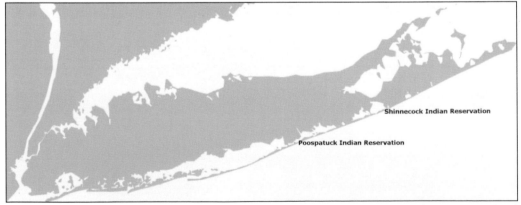

Shinnecock Indian Reservation

Poospatuck Indian Reservation

At the beginning of the European contact period, there were more than a dozen Long Island tribal nations, including the Montauk and Manhasset on the eastern end of the island and the Unkechaug, Setauket, Massapequa, Matinecock, Rockaway, and Canarsee to the west. Today, the federally recognized Shinnecock and the state recognized Unkechaug Nation at Poospatuck occupy the island's only two reservations. (Map of Long Island, NY; 29.08.2006; NY; Author: Timo Forcheim [Tzign].)

The Shinnecock are known as the "People of the Shore" and the "People of the Stony Shore," interchangeably. This picture shows that area beaches and cleansing waters where the Shinnecock have harvested fish and shellfish for centuries are also rich with plankton and stones smoothed and polished by the tides. (Photograph by Beverly Jensen.)

Giant rocks appear on tribal lands in Westwoods, Hampton Bays. This site off the Peconic Bay has large rocks along the shore, which have been a part of tribal shore lore for generations. In the 1940s, tribal member Lace Eleazer (left) was photographed with relatives there, including Nettie Cuffee Eleazer (facing the camera). (Courtesy of Eugene E. Cuffee II.)

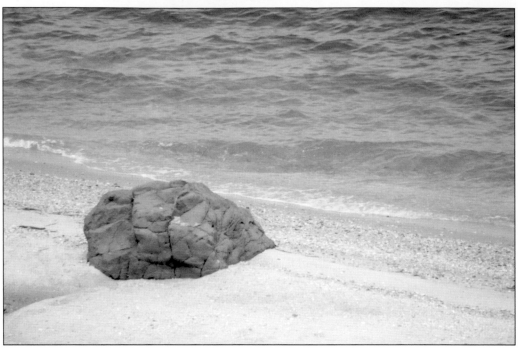

A rock of ages can be found at the shoreline of the tribal beach in Westwoods. It has probably been there since the last Ice Age and if left undisturbed will remain a distinguished and familiar marker for future generations of Shinnecock. (Photograph by Beverly Jensen.)

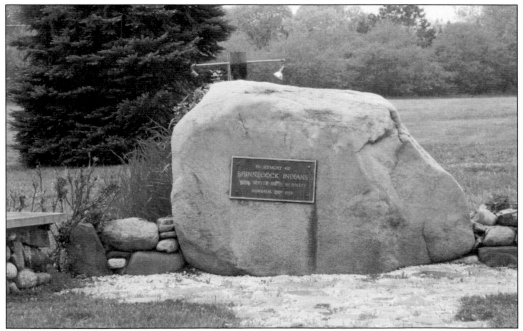

Another such rock was removed from the tribal beach at Westwoods, placed at the reservation flagpole, and embellished with a plaque honoring the Shinnecock men and women who served in the US military defending the Mother Land America. The rock is now a permanent fixture at the Shinnecock Reservation flagpole area. (Photograph by Beverly Jensen.)

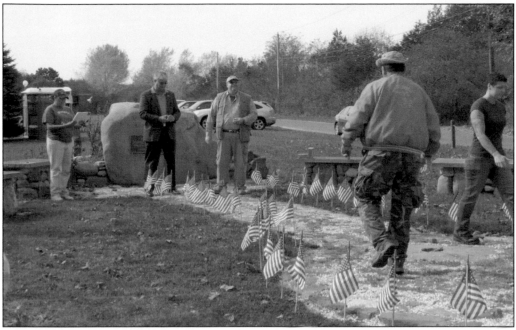

At an annual Memorial Day ceremony at the Shinnecock flagpole, veterans walked to the flagpole memorial on a stone path decorated with American flags. As the homeland of the American Indian, Native American nations—as a whole—pay special honor to veterans for defending America. (Photograph by Beverly Jensen.)

The reservation is bordered by Heady Creek on the east where turtles, eels, mussels, crabs, and clams of hard- and soft-shell variety as well as an occasional oyster can still be found. The reservation's aquiculture efforts have been hurt by pollution and runoffs from the surrounding area. (Photograph by Beverly Jensen.)

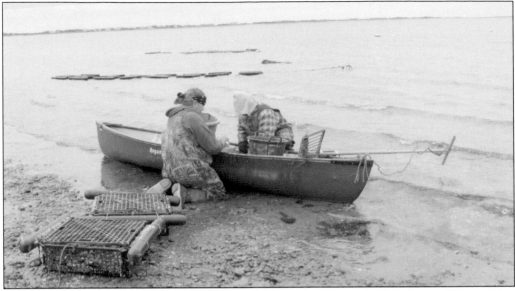

Two traditional Shinnecock baymen in a modern, metal canoe sort shellfish for size. The smallest are placed back into baskets in the water, so they can continue their growth. The larger ones are eaten in season. (Photograph by Beverly Jensen.)

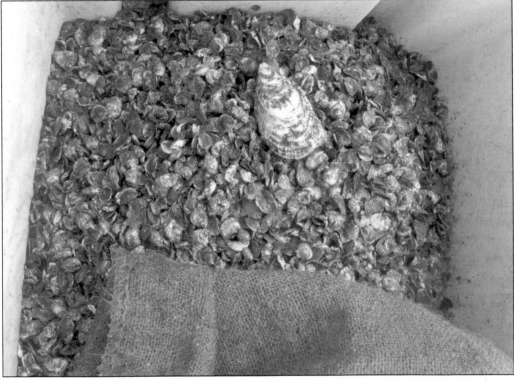

Shinnecock "chunkoo" oysters, when they are available, are a well-known delicacy in the Northeast. Tribal oyster experts say the unique flavor comes from oyster beds that are seeded in the cleanest parts of the water, away from maritime traffic, where the oysters have the best chance of cleansing themselves of pollutants. (Photograph by Beverly Jensen.)

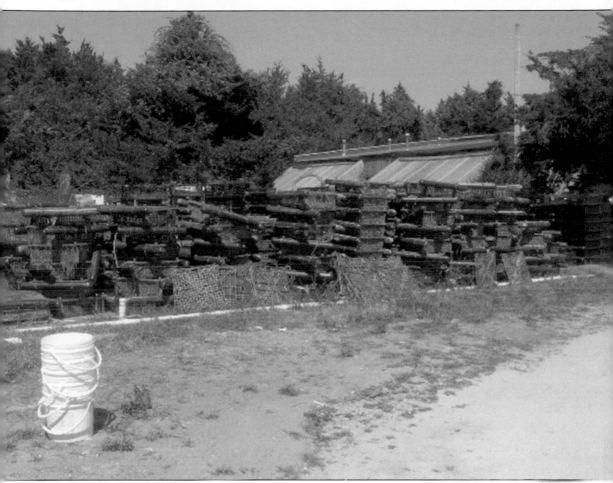

Also on the eastern side is the Shinnecock Oyster Project. In between bouts of brown tide, the project bustled with activity from the 1970s to the 1990s. Today, the once state-of-the-art building generally stands silent and in need of major repairs, with oyster baskets stacked outside. (Photograph by Beverly Jensen.)

Ryer's Creek at the southern end of the reservation is a quiet spot accessible by foot after a trek through woods or by boat from Shinnecock Bay or Heady Creek. The marshes around the creek are natural nesting places for shorebirds, and the woods just off the creek are favored camping sites of tribal members. (Photograph by Beverly Jensen.)

In this photograph, a Shinnecock comes out of Shinnecock Bay after a cleansing dip. The bay is a place of many activities of the Shinnecock, past and present, whether for Sunday school picnics, shellfish harvesting, shell and stone collecting, or congregating with family and friends. (Photograph by Beverly Jensen.)

Two

A Seafaring Heritage

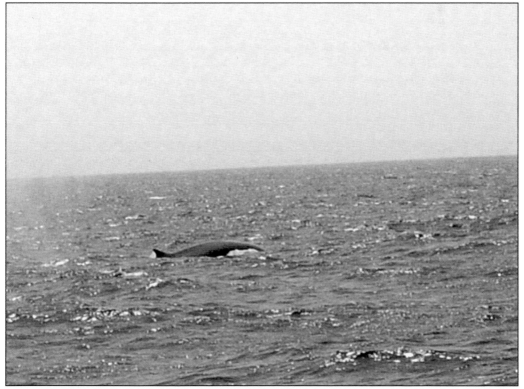

Not to be forgotten is the seafaring heritage of the Shinnecock. From their dugout canoes, they tackled the mighty Atlantic Ocean hunting and harvesting right whales and successfully towing them back to land. Because of their expertise, Shinnecock whalers of the 18th and 19th centuries were often sought out as crew on whaling vessels out of eastern Long Island seaports, such as Sag Harbor. The whale pictured here was spotted from a vessel out of Montauk in June 2014. (Photograph by Beverly Jensen.)

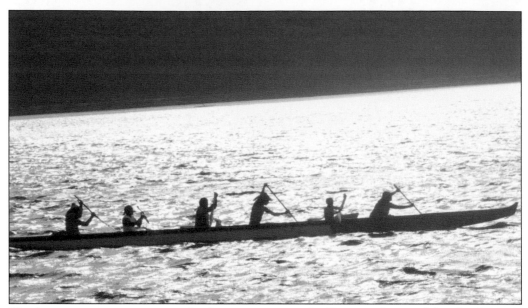

The dugout canoe was a major mode of transportation to the Shinnecock around their local waters, including out into the ocean. They also traveled by canoe across Peconic Bay to the North Fork and across the Long Island Sound to visit family and friends of the New England tribes. To pay homage to those earlier voyagers, tribal member Chenae Bullock, relative of the 19th-century seafarer Ferdinand Lee, organized a successful paddle trek across those waters in 2012, not in a dugout canoe, but in a sleek catamaran. (Photograph by Beverly Jensen.)

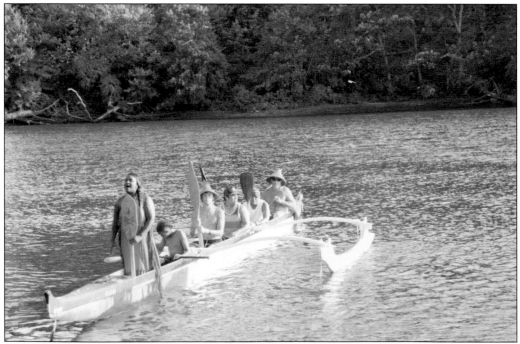

The paddlers arrived on Connecticut shores after a long pull across the waters. Included in the crew with members of the Shinnecock tribe were seafarers from the Northwest, members of the Tlingit, Salish, and Quileute tribes. (Photograph by Beverly Jensen.)

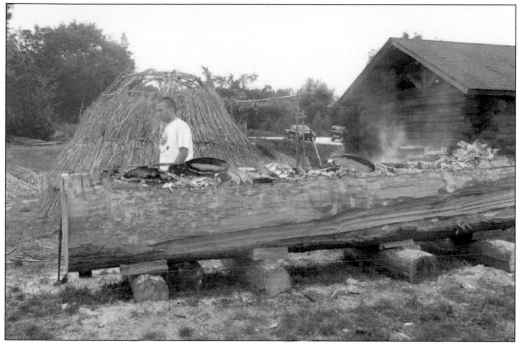

Board members and employees of the Shinnecock Nation Cultural Center and Museum agreed that the time was right for building a traditional dugout canoe. With assistance from a dugout expert from a New England tribe, the process began. (Photograph by Beverly Jensen.)

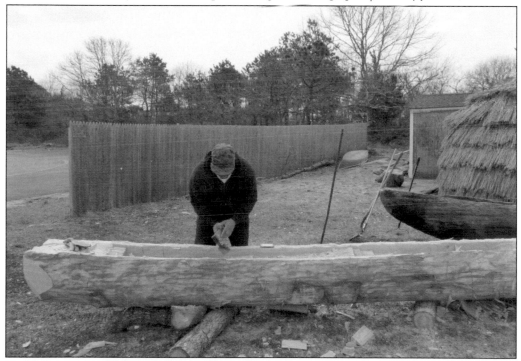

Shown here, a tribal member is engaged in the digging, scraping, and sculpting a canoe from a log, as the ancients did. (Photograph by Beverly Jensen.)

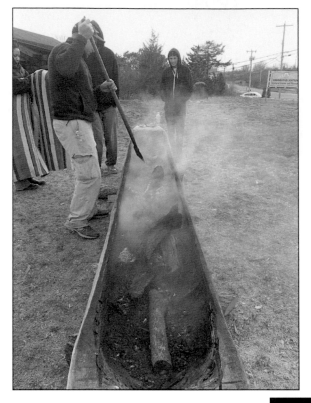

After the interior of the boat was cleaned out, a carefully monitored burning of excess wood took place. (Photograph by Beverly Jensen.)

Except for hints of charring from the burning process, the finished product appears to be seaworthy and ready to be put to the test. The dugout canoe has long been revered as a trusted vehicle for travel along the waterways, the Long Island Sound, bays, rivers, and the Atlantic Ocean for Northeast tribes. (Photograph by Beverly Jensen.)

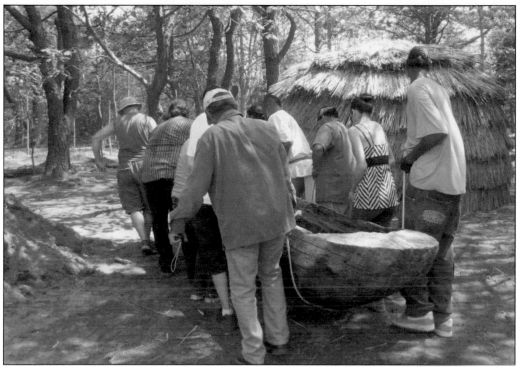

The canoe is carted to the water at Shinnecock Bay for a maiden voyage. It is with the hope that the canoe will not only float, but will float well and safely hold the weight of two adult males. (Photograph by Beverly Jensen.)

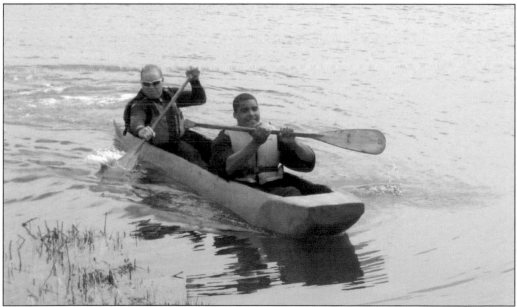

The maiden voyage clearly shows the project has been a success. The canoe floats and holds two men comfortably, and the months spent completing the project have come to a triumphant and water-worthy conclusion. The canoers are, from left to right, Mataukus Tarrant and Shane Weeks. (Photograph by Beverly Jensen.)

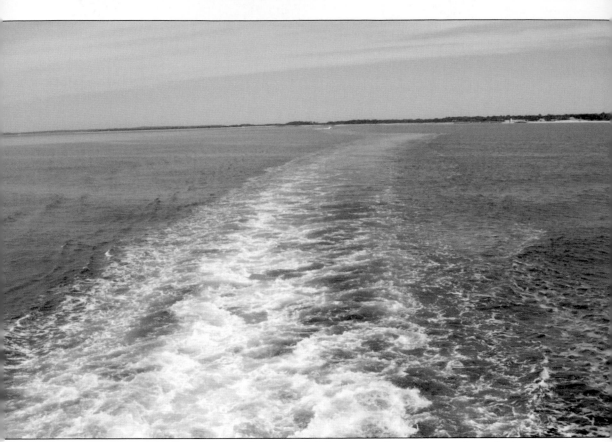

As can be seen in the photograph, a wake left by a motorboat plowing through the water is a bit stronger than the wake of a canoe paddled by people or a sailing ship propelled by winds. (Photograph by Beverly Jensen.)

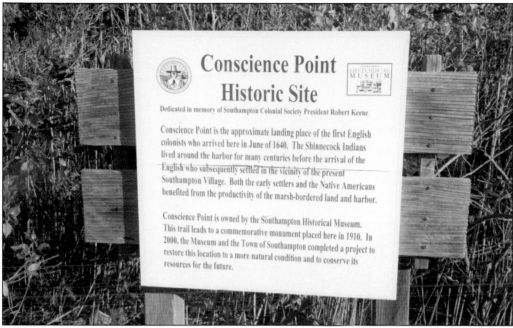

Conscience Point is the place where seafaring pilgrims from Lynn, Massachusetts, first landed in Shinnecock territory, now known as the town of Southampton, in June 1640. The official seal of Southampton Village shows a friendly Shinnecock Indian meeting a pilgrim at the shore. (Photograph by Beverly Jensen.)

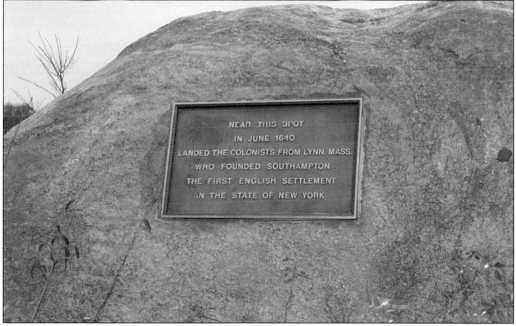

A close-up of the Conscience Point rock shows a plaque commemorating the English settlers who founded Southampton; neither the rock nor the Conscience Point sign mention that Shinnecock Indians helped the settlers survive the first winter in the new territory. (Photograph by Beverly Jensen.)

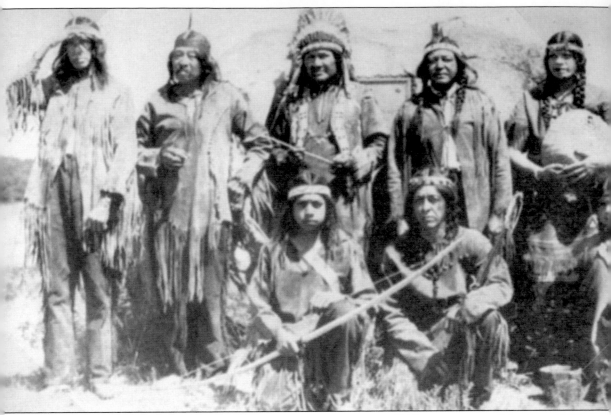

The Shinnecock Indians pictured here were participants in a 1915 reenactment of that June 1640 arrival and friendly greeting. They are, from left to right, (first row) David Martine, Anthony Beaman, and Marjorie Martine; (second row) Eugene E. Cuffee I, Charles Bunn, Charles Martine, Eliot Kellis, and Osceola Martine. (Courtesy of the Southampton Historical Society.)

Three

ART FOR A PURPOSE

Charles Sumner Bunn (1865–1952), Shinnecock/Montauk, was a Shinnecock tribal trustee and an elder of the Shinnecock Presbyterian Church. A professional guide, hunter, and decoy carver, he was also the owner of a catboat, the *Dore E*, on which he took boating parties out on local waters. Great-grandson David Bunn Martine said his great-grandfather went into New York City by train every year to a decoy show to sell his own decoys. New York was a good place to make contacts with his many clients during the golden years of shorebird hunting along the Long Island/New England coast. (Photograph by Richard T. Slattery; decoy collection courtesy of Lyle Smith, Shinnecock.)

Eugene E. Cuffee I (1866–1941) was also a tribal trustee and noted decoy carver. His decoys, some of which are distinguished by the drop wing, as in the miniature pheasant shown in the picture, are collectors' items, selling for thousands of dollars at art and decoy shows around the country. Some of the Cuffee decoys were also made with removable heads. Eugene E. Cuffee I was the son of Warren Cuffee, who died on the ship the *Circassian* when it sank off Mecox Bay in a snowstorm in December 1876. (Photograph by Richard T. Slattery; decoy collection courtesy of Lyle Smith, Shinnecock.)

Norman Smith was also noted as much for his decoys as for his paintings and drawings. He was the father of long-serving Shinnecock trustee Brad Smith, and this picture includes a duck carved by another of his sons, Tony Smith. Norman Smith also designed and painted the Shinnecock Powwow stage. It was designed as a semicircle and painted to represent a powwow drum, the only such dance stage in Indian Country. (Photograph by Richard T. Slattery; decoy collection courtesy of Lyle Smith, Shinnecock.)

Keeping decoy-making in the family, Norman Smith's nephew Lyle Smith has created decoys that include a great blue heron in the drop-wing style of his relative Eugene E. Cuffee I. He is the owner and is an avid collector of the other decoys shown in these pages. This blue heron was placed on the deer antler stand in memory of his brother, the late Larry Smith. (Photograph by Richard T. Slattery.)

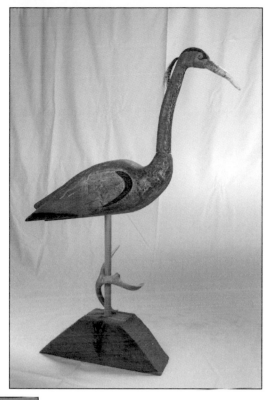

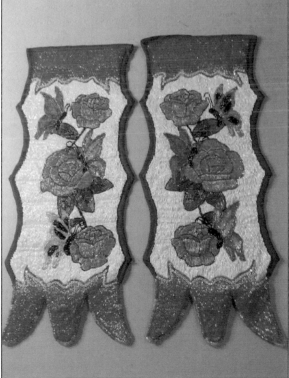

Side drops are worn in male fancy dance regalia. As the name suggests, they drop from the waist and hang down each side of the dancer, creating splashes of color as the dancer moves around the dance arena. These side drops were beaded in an eastern woodlands floral pattern by Shinnecock tribal member Nekosis Hunter. (Photograph by Beverly Jensen.)

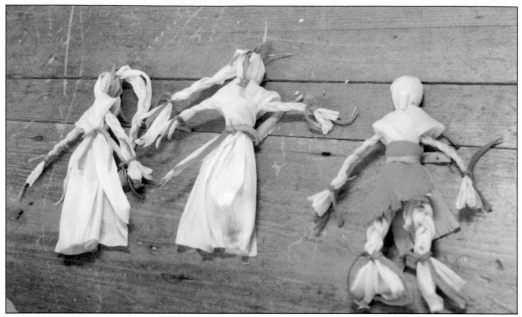

Keying in on a tradition that has survived more than a thousand years, Shinnecock tribal member Shavonne Smith produced cornhusk dolls for the Sunday school children. Although cornhusks are not as available on the reservation as they once were, since Shinnecock corn farming diminished over the past few decades, supplies can be gathered from local produce stands and supermarket vegetable bins. (Photograph by Beverly Jensen.)

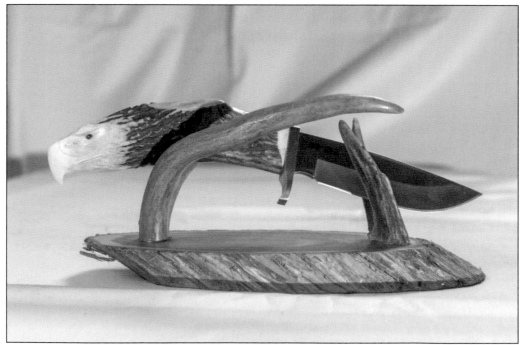

This knife handle, carved to resemble an eagle, was made by Shinnecock artist Dennis King. He also fashioned the deer horn knife stand and the stand's wood base from polished cedar. (Photograph by and courtesy of Richard T. Slattery.)

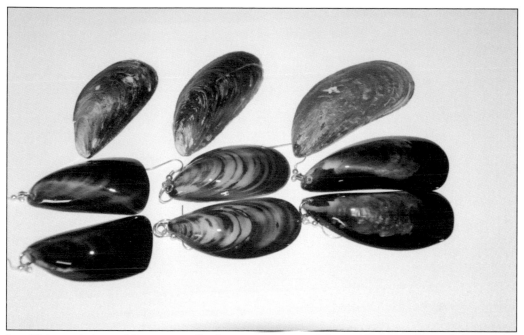

In addition to being a delicacy at seafood restaurants, mussels have other uses. Their shells are also used as jewelry. A bit more delicate than hard clamshells, mussel shells are becoming popular as earrings and necklaces. Tribal craftsman Edward Terry makes earrings from these shells, which grow in abundance along Long Island shores. (Photograph by Beverly Jensen.)

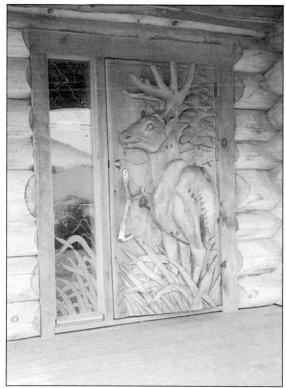

The Shinnecock Nation Cultural Center and Museum's main front door is carved from laminated blond woods. The design is dominated by a large white-tailed deer, with whales on the inside. The handle is a bone antler. This door was donated by a benefactor of the Shinnecock museum in the early 1990s and was made by Glen McCune (non-Indian) of Michigan. (Photograph by Beverly Jensen.)

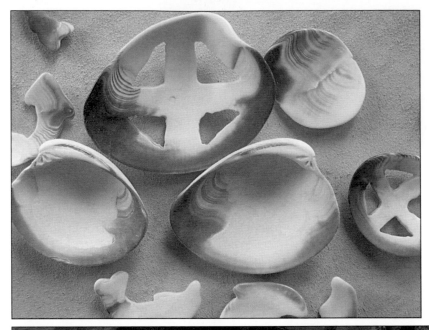

These shells were carved and/or polished by wampum artisan Herman "Chuck" Quinn of Shinnecock. (Photograph by Beverly Jensen.)

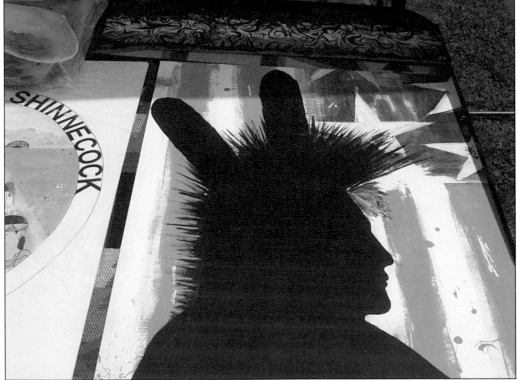

The late Jason King was an elected member of the now defunct Shinnecock Nation Tribal Council. He was also an artist, some of whose work was exhibited in 2013 at an art show in Agawam Park in Southampton by his older brother, former trustee chairman Randy King. This picture is a silhouette of a Native American man in dance regalia against the American stars and stripes. (Photograph by Beverly Jensen.)

A second painting by the late Jason King, who was also a male traditional powwow dancer, seems to suggest an eagle-feathered Native American figure wrapped in a blanket and gazing up longingly at a painting of American stars. The words *Hoka Hey* appear in the upper left corner, attributed by many as coming from Sioux warrior Chief Crazy Horse before he went into battle. (Photograph by Beverly Jensen.)

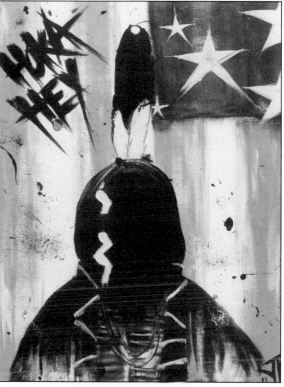

One of the Shinnecock Nation Cultural Center and Museum recent shows included a regalia exhibit. The exhibit highlighted clothing concepts worn by tribal members for various functions and dances, such as buckskin traditional, jingle contemporary, and colorful fancy. Also highlighted were moccasins and leggings of various styles. (Photograph by Beverly Jensen.)

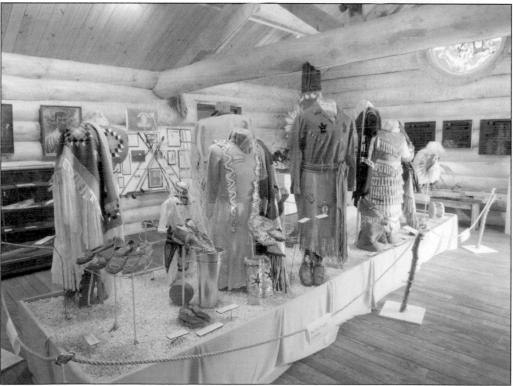

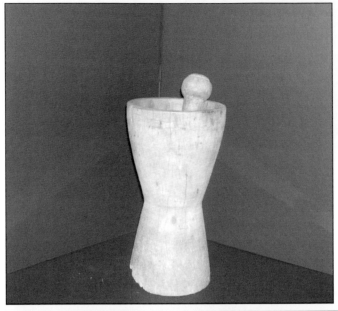

Shinnecock herb mortar and pestle sets were used to process dried medicinal plants and herbs for traditional medicines. The wood used was a hardwood such as oak, Pepperidge, or tupelo. These were in use up through the 1950s by ordinary Shinnecock people or medicine people, men or women. Originally, these were burned and hollowed out of a tree log. Later, they were turned on a wood lathe. The pestle would have originally been a finely smoothed hard stone. (Courtesy of the Shinnecock Nation Cultural Center and Museum.)

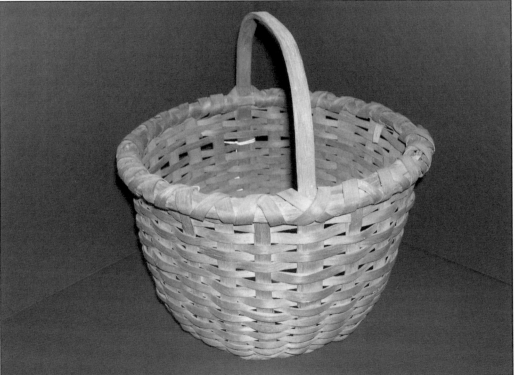

This style of Shinnecock berry basket made of maple in the plain-plaited, splint style is typical of the post–European contact style that became the main kind of baskets sold and used as a utilitarian item, predominantly through the early 20th century. The pre-contact style of carrying container was made of dyed plant fiber. Some traditional basket makers of the tribe were Joshua Kellis, David Kellis, Marguerite Kellis, James Kellis, and Alice Osceola Bunn Martinez. (Courtesy of the Shinnecock Nation Cultural Center and Museum.)

Four

A FUTURE FROM THE PAST

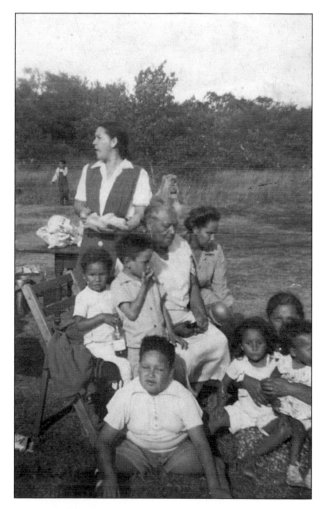

Every summer, the Shinnecock Presbyterian Church holds a Sunday school picnic, usually at one of the tribal beaches. This 1944 Sunday school picnic took place on the lawn of Edna Eleazer. Pictured are, from left to right, (first row) Douglas Carl and Mabel Dyson holding Eleanor Franklin (left) and Phyllis Butler (right); (second row) Joyce Franklin, Gary Carl, Lillian Lee, and Alice Franklin; (third row) Vivian Carle. (Courtesy of Shirley Smith.)

Marjorie Bunn Martine is shown here as a toddler. She was the daughter Osceola Bunn Martine (Shinnecock) and Charles Martine (Apache) and the mother of David Bunn Martine. (Courtesy of David Bunn Martine.)

Theodore "Doad" Cuffee was the son of Frances Bunn and Warren N. Cuffee, who drowned during the *Circassian* tragedy. (Courtesy of Eugene E. Cuffee II.)

Natalie May Cuffee (1902–1915) was the daughter of tribal trustee and decoy carver Eugene Cuffee and Ida Beaman. (Courtesy of Eugene E. Cuffee II.)

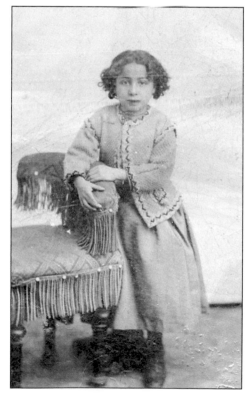

Ada Bunn is seen here as a little girl. She is the grandmother of tribal elder Shirley Smith. (Courtesy of Shirley Smith.)

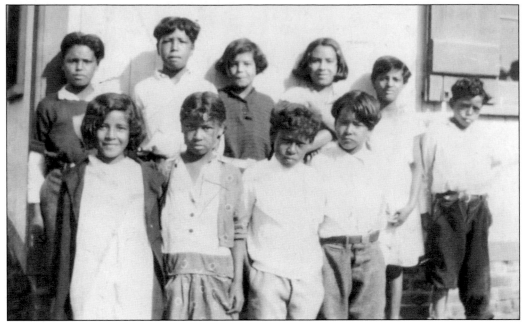

Schoolchildren are pictured in the 1930s. They are, from left to right, (first row) Julia Smith, Doris Smith, Milton Bess, and Harry Williams; (second row) James Kellis, Warren Eleazer, Eva Kellis, Alice Lee, Viola Smith, and Vincent Eleazer. (Photograph possibly by Ed Sidor; courtesy of the Shinnecock Nation Cultural Center and Museum.)

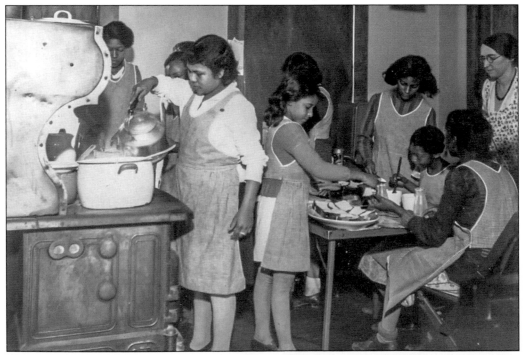

Shinnecock schoolchildren are pictured working in the classroom in this 1930s photograph. As was the custom at the time, the children were taught "practical" skills, such as cooking and sewing, along with their ABCs. (Courtesy of the Shinnecock Nation Cultural Center and Museum.)

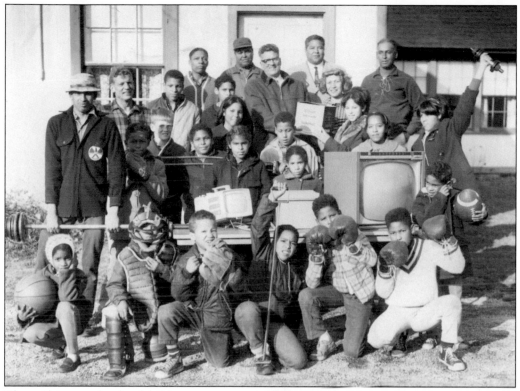

These Shinnecock schoolchildren pose in the 1960s. The Shinnecock School closed in the late 1940s, and Shinnecock children were sent by bus to Southampton schools. However, they still utilized their old school for afternoon programs. In this photograph, the children had just received donations of sports and entertainment equipment. (Courtesy of Shirley Smith)

Alyssa Sunbow Gomez is the daughter of Lori Beth Gomez (Shinnecock) and the late Phillip Gomez of Taos Pueblo. (Photograph by Beverly Jensen.)

Alexandria Spring Water Gomez is also the daughter of Lori Jensen Gomez and the late Phillip Gomez of Taos Pueblo. (Photograph by Beverly Jensen.)

The Little Blanket dancer is Alexis Sky Troutman, great-granddaughter of Judith Trotman and Lynda Hunter. Children of Shinnecock learn powwow social dances at a very early age, almost before they can walk. (Photograph by Beverly Jensen.)

Juan Javier Gamble, pictured here, is the grandson of trustee Daniel Collins Sr. and the great-grandson of Henry Bess, a ceremonial chief of the Shinnecock Powwow. Henry Bess played a major role in establishing the Shinnecock Powwow as an annual event. (Photograph by Beverly Jensen.)

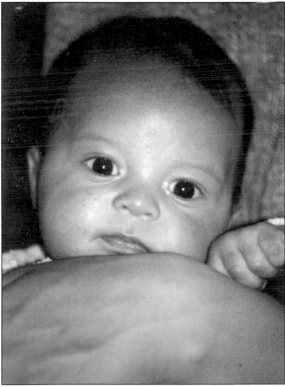

The little baby boy in this photograph is Elijah Storm Star, the son of Lori Gomez and the late Phillip Gomez of Taos Pueblo. (Photograph by Beverly Jensen.)

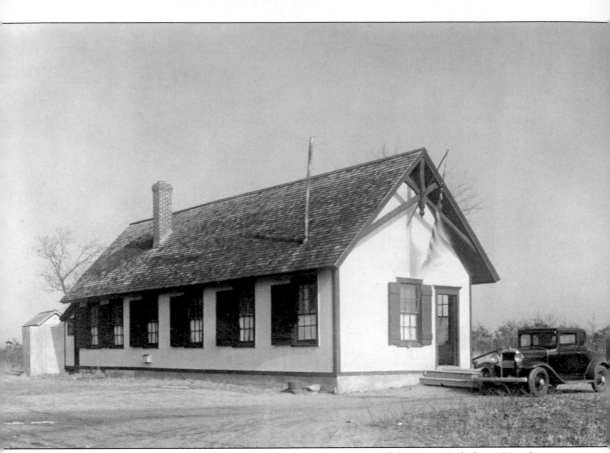

The Shinnecock School was brought into being by an act of the New York State Legislature on April 19, 1831, and enacted on April 28, 1841. The school had eight grades, and several Shinnecock people served as teachers. The first Shinnecock teacher was Mary Rebecca Bunn Lee. The first building burned in 1874 and was replaced by the state in 1875, which in turn burned down on the night of November 6, 1967. This photograph was taken in the 1930s. (Courtesy of the Shinnecock Nation Cultural Center and Museum.)

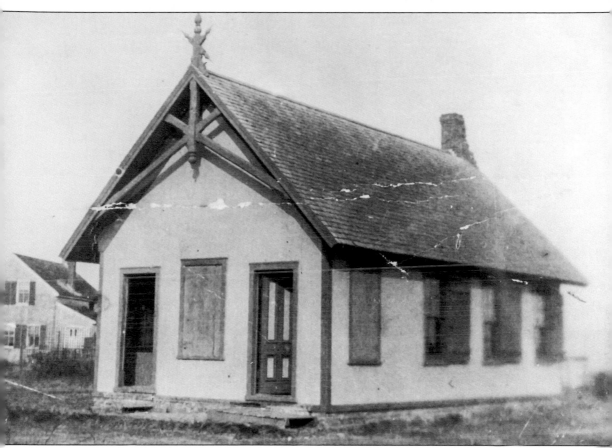

The Shinnecock School is pictured here in the 1950s, when a second front door was added. (Courtesy of the Shinnecock Nation Cultural Center and Museum.)

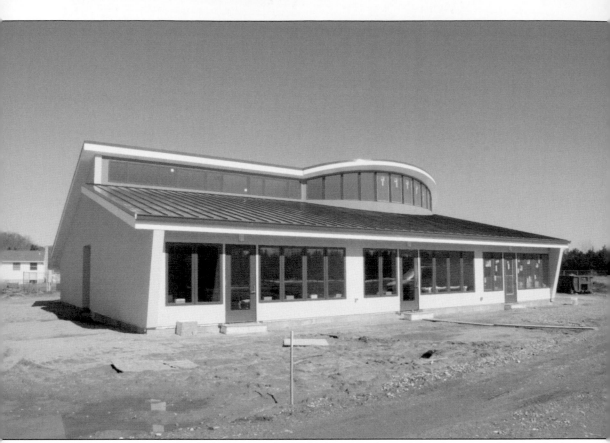

The tribe's newest school, the Wuneechanunk Shinnecock Pre-School, a state-of-the-art facility that opened in 2015, is for early childhood education, so that the tribe's future—its youngest citizens—are immersed in Shinnecock culture. (Photograph by Beverly Jensen.)

Five

PLACE OF THE HEART

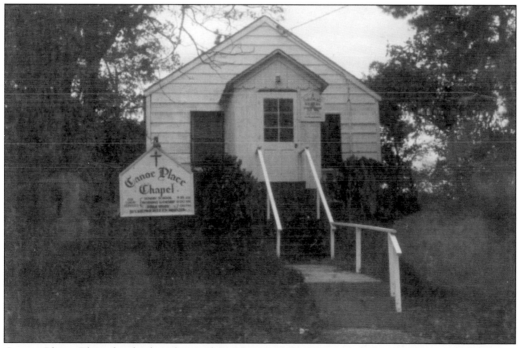

Canoe Place Chapel, which is located in Hampton Bays, is important in Shinnecock history because before the reservation was established in 1859, a number of Shinnecock people resided in the area and worshiped in the chapel, and some were buried in the small graveyard behind the structure. (Courtesy of Eugene E. Cuffee II.)

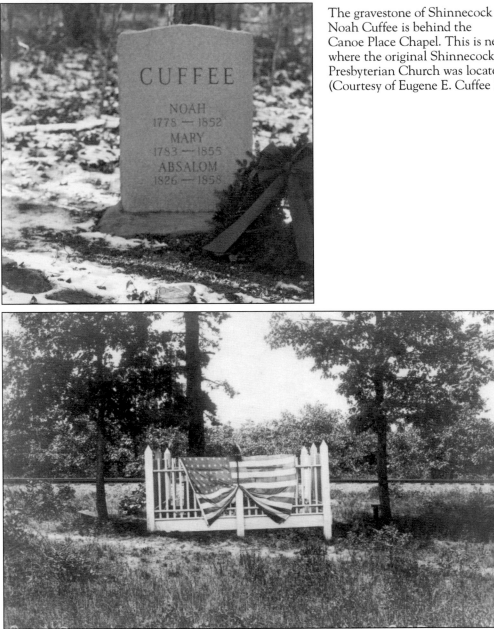

The gravestone of Shinnecock Noah Cuffee is behind the Canoe Place Chapel. This is near where the original Shinnecock Presbyterian Church was located. (Courtesy of Eugene E. Cuffee II.)

This photograph of the Hampton Bays gravesite of the Reverend Paul Cuffee was taken by Cortland Smith in 1933. Paul Cuffee, the son of Peter Cuffee and Jane Peters Cuffee, was born at Brookhaven. Rev. Peter John Cuffee, his grandfather, was a Congregationalist and had churches at Wading River, Poospatuck, Islip, and Canoe Place (also known as Good Ground or Hampton Bays). A number of these churches were probably mostly native, but he preached to white and Indian alike. After his ordination in 1790 by the Congregational (later Presbyterian) Church, Rev. Paul Cuffee also ministered at Montauk. He is credited with bringing what is now known as June Meeting Sunday into the native churches at Shinnecock and Poospatuck. Originally, this event was a spring welcoming celebration and also served as a communal feast with visiting tribes. (Courtesy of the Shinnecock Nation Cultural Center and Museum.)

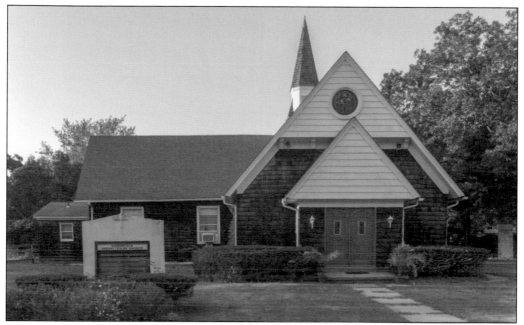

The left side of the L-shaped Shinnecock Presbyterian Church was the old church and is now called the parish hall. This section was originally located at Canoe Place, near the present Canoe Place Chapel. After the reservation was established in 1859, the section was brought across the ice of a frozen Shinnecock Bay. Blown off its foundation during the 1938 hurricane, the old church was placed in an east-west direction, and a new sanctuary was added to it facing south. (Photograph by Richard T. Slattery.)

The Shinnecock Presbyterian Church is the worship place of the oldest continuous reformed Indian congregation in the United States. (Photograph by Richard T. Slattery.)

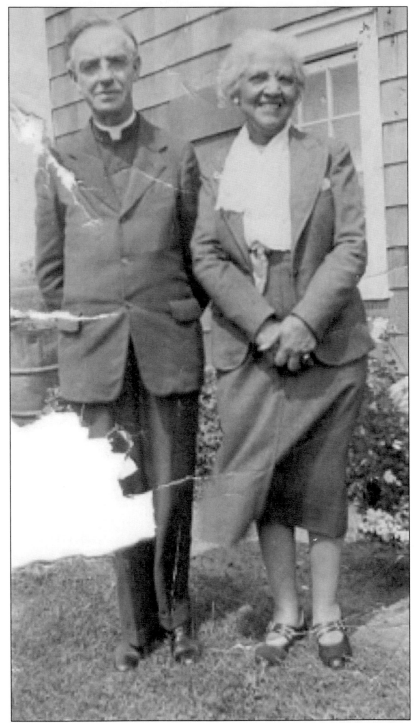

The minister of the Shinnecock Presbyterian Church in the 1940s and early 1950s was Rev. J. Raymond Vaughn, shown here with parishioner Addie Cuffee Cogsbill. Reverend Vaughn conducted the first wedding in the new sanctuary when Bessie Selina Quinn married Thomas Marshall in 1946. (Courtesy of the Shinnecock Nation Cultural Center and Museum.)

A tribal member, the Reverend Michael Smith, a graduate of Princeton Theological Seminary, was installed as a Shinnecock pastor in the 1980s. Prior to Shinnecock, Reverend Smith served in Arizona as associate executive for Indian Ministries Synod of the Southwest of the Presbyterian Church. Reverend Smith is the son of Shirley and the late Elmer Smith. During his pastoral residency, he and his wife, Ana, have raised four children: Michael, Deanna, Christina, and Matthew. (Courtesy of Shirley Smith.)

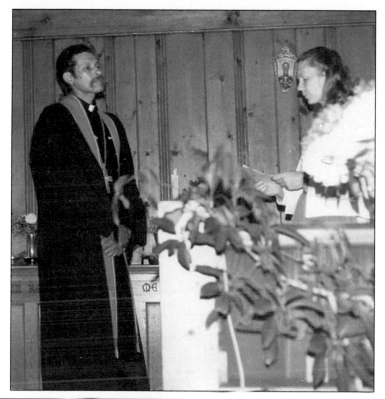

Eliot Smith is shown here with elder Eva Kellis Smith. Eliot is ambassador of goodwill for the Shinnecock Presbyterian Church. (Photograph by Beverly Jensen.)

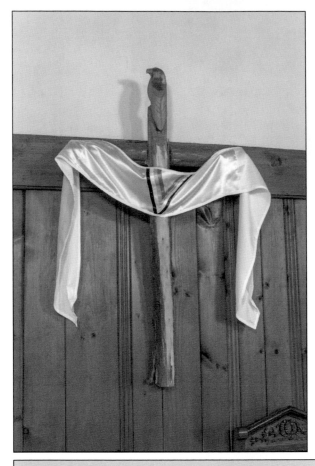

A distinguishing feature of the Shinnecock Presbyterian Church is a large cross with a carved eagle head. The cross was carved by tribal member Dennis King and represents Native American belief that the eagle, which flies highest of all birds, assists in delivering prayers to God. (Photograph by Richard T. Slattery.)

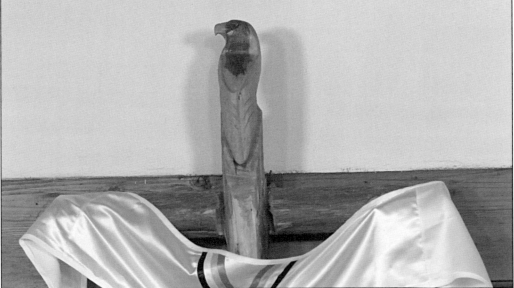

Pictured is a close-up of the eagle head carved on a cross at the Shinnecock Presbyterian Church. (Photograph by Richard T. Slattery.)

The *Circassian* memorial is located at the Shinnecock Cemetery, where it commemorates another heartbreak of the Shinnecock Indian Nation. It was built in "loving memory" of 10 young Indian men—husbands, fathers, sons, uncles, brothers, and cousins—who drowned December 30, 1876, trying to help the British cargo ship *Circassian*, as it foundered and sank off Mecox Bay, Bridgehampton. Among the dead were David W. Bunn, J. Franklin Bunn, Russell Bunn, William Cuffee, George Cuffee, Warren Cuffee, Oliver Kellis, Robert Lee, John Walker, and Lewis Walker. (Photograph by Beverly Jensen.)

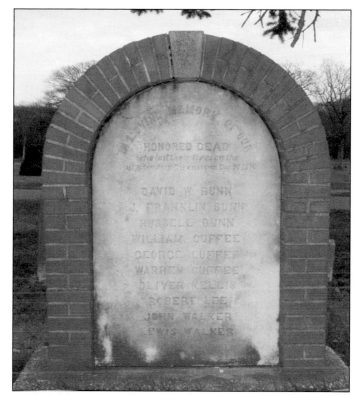

This photograph is of the Atlantic Ocean off Mecox Bay, Bridgehampton, where the *Circassian* tragedy occurred. (Photograph by Beverly Jensen.)

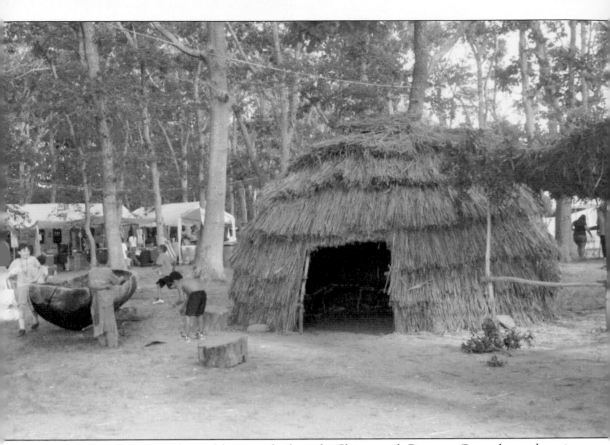

This wickiup, a traditional hut, was built at the Shinnecock Powwow Grounds as a learning experience for both the builders and the powwow visitors in 2012. This wigwam, or *witu*, would have been made originally with white cedar poles, bent and tied into a frame with inner bark cordage, with overlapping rows of meadow or sea grass thatched and/or sewn on with a large bone or wood needle or awl. Other styles of wigwams were covered with cattail reed woven into mats as well as tree bark fixed into place with bark ties and thin wood poles used to cover the wooden frame. (Photograph by Beverly Jensen.)

Six

WOMEN OF THE SHORE

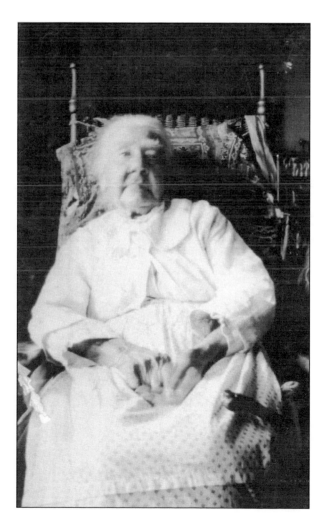

Mary Hugh Waukus (1767–1867) is the mother of Cynthia Walker Bunn. This is the oldest known photograph of a Shinnecock Indian. (Courtesy of Eugene E. Cuffee II.)

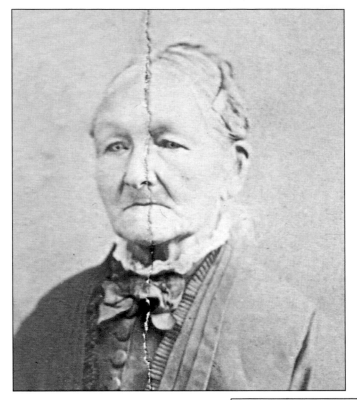

Cynthia Walker Bunn (1800–1881) is the daughter of Mary Hugh Taukus and the wife of David Bunn. Her children were Abraham Bunn, (lost at sea), Mary Rebecca Bunn Lee, George Bunn, J. Franklin Bunn (lost in the *Circassian* disaster), and Thomas Bunn. Cynthia was careful to save her husband's whaling income. She was a seamstress and worked in Southampton. She died of smoke inhalation from her house fire in 1881. (Courtesy of the Shinnecock Nation Cultural Center and Museum.)

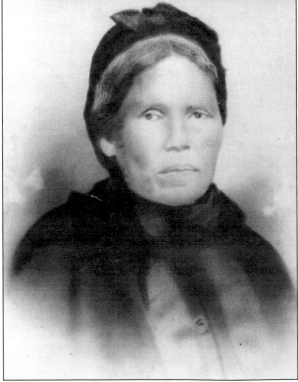

Charity Bunn Kellis (1818–1897) was the daughter of Charles Kellis. (Courtesy of the Shinnecock Nation Cultural Center and Museum.)

Mary Ann Cuffee (1817–1903) was the mother of Mary Emma Bunn. Married to Agee Cuffee, she was one who could still speak some of the Shinnecock language, according to Osceola Bunn Martinez. She said to her daughter-in-law Mary Emma Bunn, "Cease your weeping child—there's work to be done—there's time enough for that," after Mary's husband, David Waukus Bunn, had drowned on the *Circassian* in 1876 off Bridgehampton. (Courtesy of Eugene E. Cuffee II.)

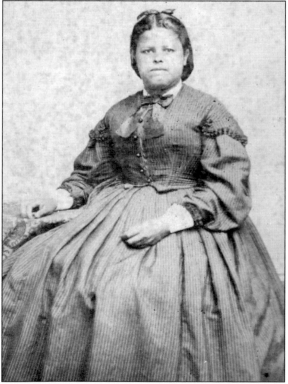

Ellen Kellis Cuffee (1839–1916) was the wife of Wickham Cuffee (1826–1915). (Courtesy of the Shinnecock Nation Cultural Center and Museum.)

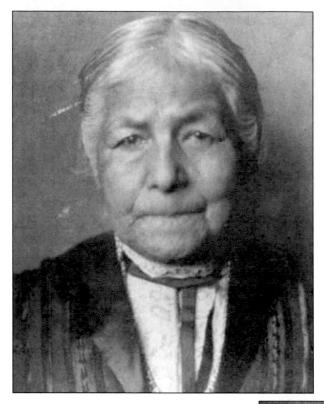

Mary Rebecca Bunn Lee (1840–1936), the first Shinnecock tribal member to teach at the old Shinnecock School, was known by many reservation people as "Aunt Becky." Her home was across the road from the Shinnecock Presbyterian Church. (Courtesy of the Shinnecock Nation Cultural Center and Museum.)

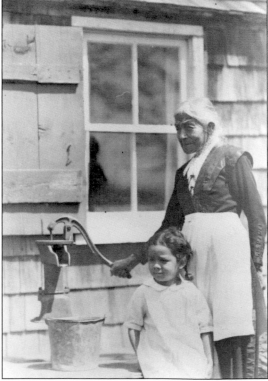

Mary Rebecca Bunn Lee is pictured at the water pump outside her Shinnecock home with her great-granddaughter Inez Shippen, who joined the US Navy when she grew up. (Courtesy Eugene E. Cuffee II.)

Mary Rebecca Bunn Lee is seen at her home with an unidentified visitor in 1933. She stands on a porch at her home on the reservation that was financed by whaling voyages of her relatives. She remembered a visit to relatives with her grandmother, who still lived in the unique traditional Shinnecock houses of thatched sea grass over a frame of white cedar poles, in the 1840s. This thatched sea or meadow grass would have been sewn onto the wood frame with a very large needle or awl made of bone or wood. She recalled that Shinnecock people were living in both wood frame houses and wigwams during the 1840s throughout the Shinnecock Hills area. (Courtesy of the Shinnecock Nation Cultural Center and Museum.)

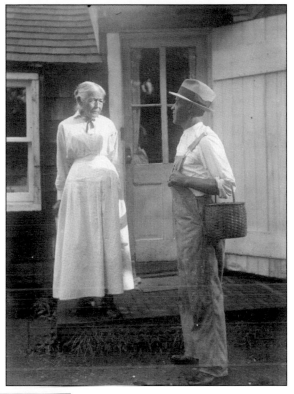

Adeline Bunn Waters (1844–1913), daughter of Sophia Waukus Bunn and James Bunn, is pictured here. (Courtesy of the Shinnecock Nation Cultural Center and Museum.)

Seen here is Anna Bunn Kellis (1845–1939), daughter of Sophia Waukus Bunn and James Bunn. (Courtesy of the Shinnecock Nation Cultural Center and Museum.)

Pictured are, from left to right, Anna Bunn Kellis, Frances Bunn Cuffee Bunn (1846–1940), and Anna Bunn Eleazer. (Courtesy Eugene E. Cuffee, II.)

Mary Emma Bunn (1847–1937) was the mother of Charles Sumner Bunn and wife of David W. Bunn, a whaler who drowned on the *Circassian* in 1876. (Courtesy of the Shinnecock Nation Cultural Center and Museum.)

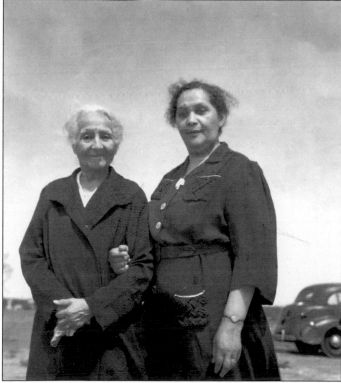

Pictured are Ada Smith Bunn (1862–1948) and her daughter Mabel Bunn Dyson, mother and grandmother of Shirley Dyson Smith, Bernice Dyson Smith, Arlene Dyson Butler, and Marion Dyson. (Courtesy Shirley Smith.)

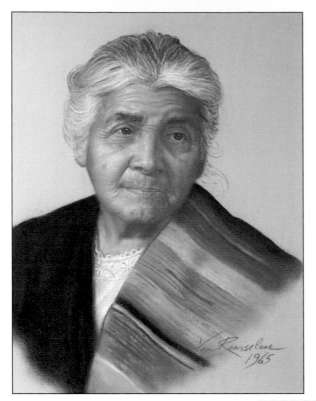

Edna Walker Eleazer (1868–1969) is seen here, as depicted in a 1965 painting by Van Ransselaer. "Miss Edna," or "Cousin Edna," as she was called, was, for a number of generations, one of the most recognized figures on the reservation. She worked well into her old age at the Southampton Library and was generally given a ride by tribal members as she walked to and from work. (Courtesy of the Shinnecock Nation Cultural Center and Museum.)

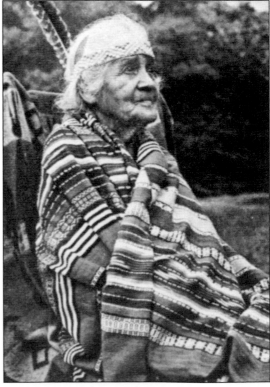

Edna Walker Eleazer is pictured at her home in the late 1960s. She was 10 years old when her father and uncle—John Walker and Lewis Walker, respectively—were lost on the *Circassian*. (Courtesy of Shirley Smith.)

Helen Smith Bunn Hendricks (1902–1993) was the daughter of Charles S. Bunn. She was the last surviving granddaughter of David Waukus Bunn, the Shinnecock whaler who drowned on the *Circassian* off Bridgehampton in 1876. Her house still stands. (Courtesy of David Bunn Martine.)

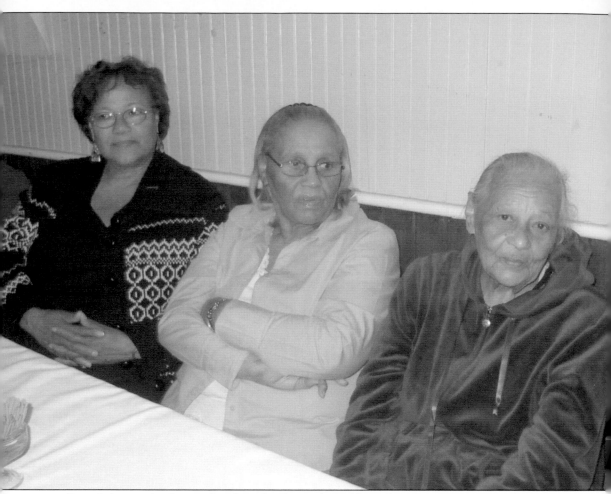

From left to right, Laurie Sanders, daughter of Alvilda and Arthur Crippen Sr.; Florence Lee Etheridge, daughter of Ferdinand and Esther Lee; and Alvilda Crippen (of Seminole heritage), wife of Arthur Crippen Sr., are pictured at the Shinnecock Presbyterian Church. (Photograph by Beverly Jensen.)

Tanis Phillips Scott (1918–1999),
seen here, was the daughter of Alice
Phillips. She was also the sister of James
Phillips. (Courtesy of James Phillips.)

Seen here is Camille Smith (facing
the camera), wife of Tom Smith
and matriarch of one of the largest
reservation families. Their children
include Sewell, Charles, Elmer, James,
George, Arlene, Emily, Rose, Maudelle,
and Doris. (Courtesy of Shirley Smith.)

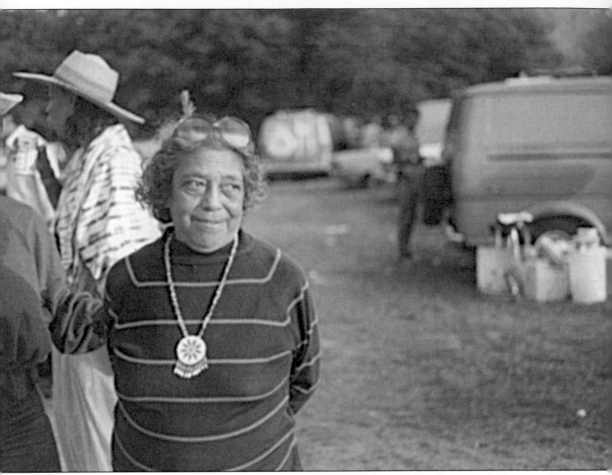

Beatrice Eleazer Smith, sister of Warren Eleazer, is pictured at a 1990s Shinnecock Powwow. "Aunt Bea," as she was known, was an enthusiastic participant in reservation life and is particularly remembered for her joyous contributions to the Shinnecock Presbyterian Church choir. (Courtesy of Beverly Jensen.)

Florence T. Crippen (1924–2014) was the youngest daughter of Emmett (Montauk) and Harriett R. Lee Crippen (Shinnecock). (Photograph by Beverly Jensen.)

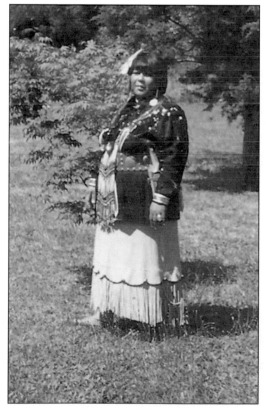

Cheryl "Toot" Omega Crippen Munoz (1948–2010) was the youngest of nine children of Arthur and Alvilda Crippen. (Courtesy of Wayne Red Dawn Crippen.)

Pictured here is Lori Jensen Gomez, the daughter of Robert and Beverly Jensen and the wife of the late Phillip Gomez of Taos Pueblo. She is also the mother of Alyssa Sunbow, Alexandria Spring Water, and Elijah Storm Star Gomez. (Photograph by Jen Anderson.)

Attorney Marguerite Smith is the daughter of Eva Kellis Smith and the sister of Josephine Smith and Eva Smith Chase, MD. (Photograph by Beverly Jensen.)

Seven

MEN OF THE SHORE

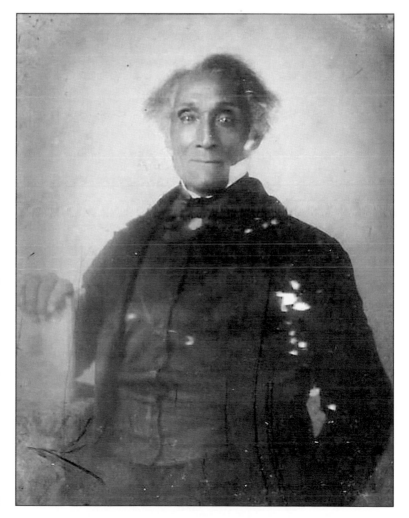

Vincent Cuffee (1793–1879) was the son of Rev. Paul Cuffee. His wife was Sarah Bunn (1797–1856), daughter of James Bunn and Mary Dency Cuffee. Their children were Fannie Cuffee, who married Rufus H. Smith, and Wickham Cuffee, who married Ellen Kellis. Wickham Cuffee looks very similar to his father, Vincent Cuffee. (Courtesy of the Shinnecock Nation Cultural Center and Museum.)

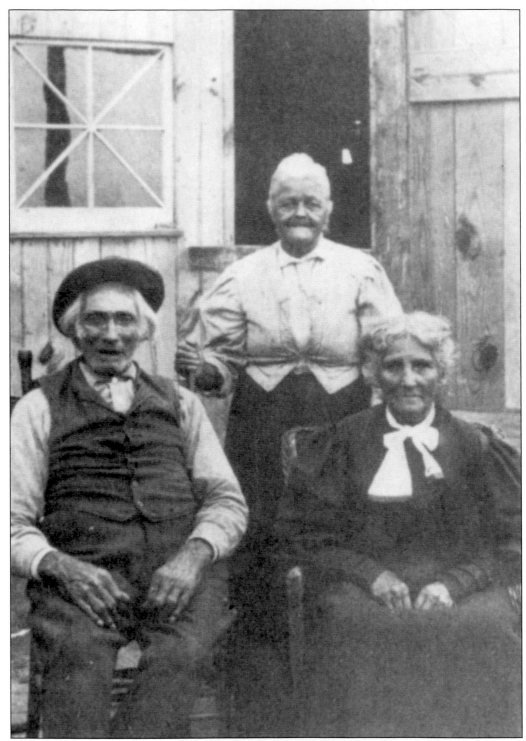

Pictured here are Wickham Cuffee (1826–1915), his sister Francis Cuffee Smith seated next to him, and his wife, Ellen Kellis Cuffee (1839–1916), standing behind. (Courtesy of Eugene E. Cuffee II.)

James Franklin Bunn (1837–1876) was the son of Cynthia Walker Bunn (1800–1881). He was lost in the *Circassian* disaster. His siblings were Abraham Bunn (lost at sea), Mary Rebecca Bunn Lee, George Bunn, and Thomas Bunn. (Courtesy of the Shinnecock Nation Cultural Center and Museum.)

Wickham Cuffee (1826–1915), husband of Ellen Kellis (1839–1916), was the grandson of the Reverend Paul Cuffee (1757–1812), whose church was in Canoe Place. His grave is maintained just off Montauk Highway. Rev. Paul Cuffee's grandfather was Rev. Peter John Cuffee, who was born at Hay Ground sometime between 1712 and 1715. Rev. Peter John was a part of the Great Congregationalist Revival of 1741–1744. Wickham Cuffee was the grandfather of Lois Marie Hunter (1903–1975), also known as Princess Nowedonah. (Courtesy of the Shinnecock Nation Cultural Center and Museum.)

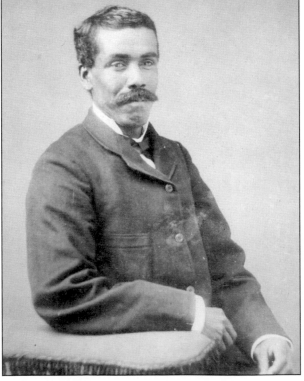

Lewis Whitmore Beaman (1850–1898) was the son of Thomas Beaman and Mary Kellis. (Courtesy of the Shinnecock Nation Cultural Center and Museum.)

Milton W. Lee Jr. (1861–1920), the only child of Milton W. Lee Sr. and Mary Rebecca Bunn Lee, married Adelaide Kellis. He sailed on only one whaling voyage to Greenland between 1879 and 1881. Once, while his ship was frozen in, Eskimo women came aboard and did their traditional dances. He became a farmer and shorebird hunter. He also enjoyed opera, theater, and sailing on his boat, the *Ruth E.* He was a trustee of the Shinnecock tribe and elder of the Shinnecock Presbyterian Church. He liked taking care of people and organized a group of young men who helped old whalers and other men who needed care as they became older. (Courtesy of the Shinnecock Nation Cultural Center and Museum.)

Milton Winfield Lee Sr. (1832–1869), a whaler, was one of 10 children of James Robert Lee and Roxanna Bunn Lee of the Shinnecock Reservation. Milton married Mary Rebecca Bunn Lee, also known as "Granny Beck," the daughter of David and Cynthia Walker Bunn. She was a nanny to Teddy Roosevelt, and according to tribal elders, she knew some of the ancient Shinnecock language. She was also an early teacher at the Shinnecock one-room school on the reservation, teaching reading, writing, mathematics, language, and moral values. (Courtesy of the Shinnecock Nation Cultural Center and Museum.)

Charles Sumner Bunn (1865–1952) is seen here as he appears in a photographic portrait by Cora Jennings around the 1950s. A Shinnecock/Montauk, professional guide, hunter, and decoy carver, he was also a former trustee of the Shinnecock Nation and an elder of the Shinnecock Presbyterian Church. (Courtesy of Eugene E. Cuffee II.)

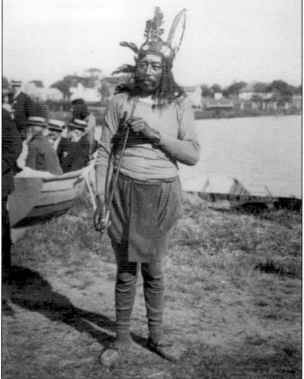

Charles Sumner Bunn (1865–1952) is pictured at Agawam Park in 1915 with a pipe at the 275th anniversary pageant of the founding of Southampton. (Courtesy of the Southampton Historical Society.)

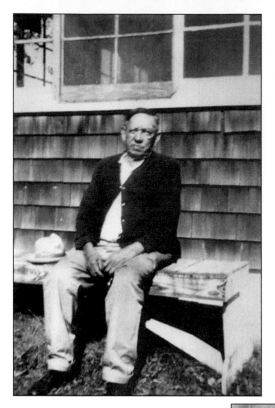

Arthur Carle (1878–1952) is pictured at Gus Thompson's house in the 1960s. He is the father of Arthur "Pete" Carle, husband of Vivian Carle. (Courtesy of the Shinnecock Nation Cultural Center and Museum.)

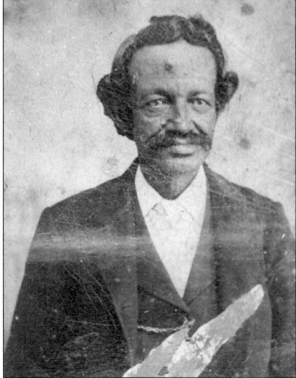

Seen here is David Kellis (1848–1905). (Courtesy of the Shinnecock Nation Cultural Center and Museum.)

Theodore "Doad" Cuffee (1873–1954) was the son of Francis Bunn and Warren Cuffee. Theodore's father was a Civil War veteran and died on the *Circassian* shipwreck off Bridgehampton in 1876. This pen and ink drawing is by David Bunn Martine. (Courtesy of the Shinnecock Nation Cultural Center and Museum.)

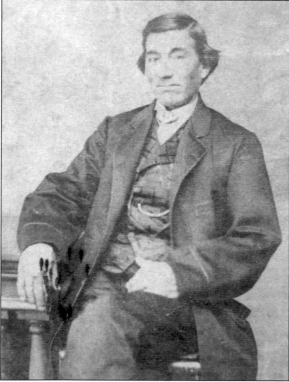

Abraham Cuffee, a Montauk whaler, is associated with the Shinnecock community at Canoe Place, also called Good Ground or Hampton Bays, as it is known today. The oldest photograph ever taken of a Shinnecock dwelling, captured during the 19th century, was located at Good Ground. It shows a fishing camp in the form of a semi-subterranean pit house of sod and a tepee-shaped storage cache nearby. Cuffee was buried near the Canoe Place Chapel, which was part of a Shinnecock Indian Church associated with Rev. Paul Cuffee at one time. (Courtesy of the Shinnecock Nation Cultural Center and Museum.)

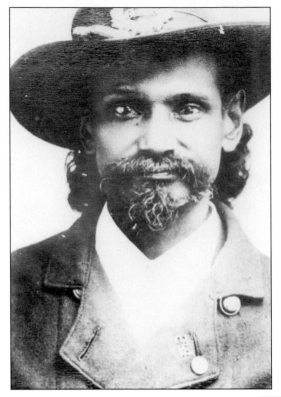

Warren Cuffee, a Montauk Indian, was a Civil War veteran who died on the *Circassian*. He was married to Frances Bunn, a Shinnecock woman, and was the father of Theodore "Doad" Cuffee. (Courtesy of the Shinnecock Nation Cultural Center and Museum.)

Everett Lee (1861–1940) was the son of Capt. Ferdinand Lee. He was the father of Harriett Ruben Lee Crippen, Bell Lee, Mary Lee Davis, and Ferdinand Lee. (Courtesy of Eugene E. Cuffee II.)

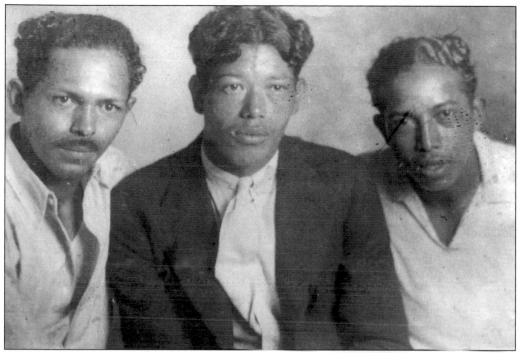

Pictured here are, from left to right, Andrew Cuffee, Claude Eleazer, and Raymond "Sonk" Cuffee. (Courtesy of Eugene E. Cuffee II.)

Alfred Davis Smith, the great-grandfather of former trustee chairman Randy King, is seen here. (Courtesy of the Shinnecock Nation Cultural Center and Museum.)

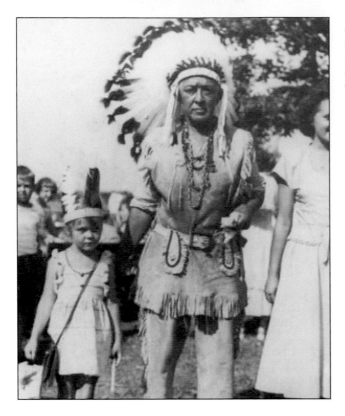

Anthony Beaman was a Shinnecock medicine man. (Courtesy of the Shinnecock Nation Cultural Center and Museum.)

Pictured is a David Walker drawing. (Photograph by Richard T. Slattery; courtesy of the Shinnecock Nation Cultural Center and Museum.)

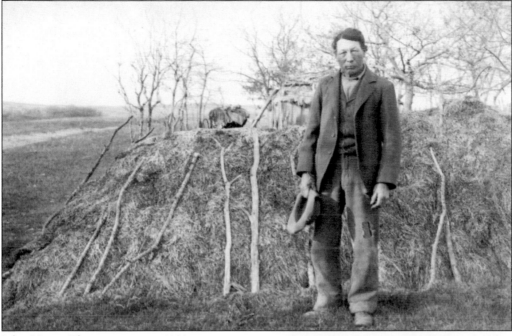

John Henry Thompson was a 1930s Shinnecock farmer with a root cellar. He was the son of J.H. Thompson (1813–1878) of Canada and Jane Cuffee (1820–1883) of Canoe Place. John Henry Thompson was a tribal trustee and worked at the Art Village, William Merritt Chase's village of art studios in Southampton. He is standing in front of a traditional Shinnecock food storage root cellar with the triangular, sod-covered roof visible behind him. The semi-subterranean structure is separate from the main house. Most houses on the reservation had root cellars directly beneath the house, but the separate "Indian barns" were used hundreds—if not thousands—of years before European contact. Early European settlers complained that their cattle would break their legs in abandoned root cellars, which were located at Shinnecock and at the Montauk Reservation "Indian fields." (Courtesy of the Shinnecock Nation Cultural Center and Museum.)

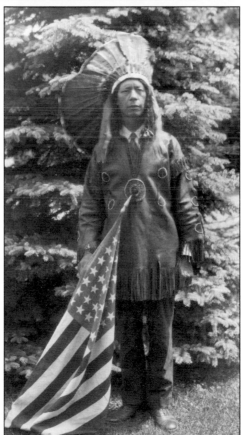

Harry B. Thompson is pictured after a 1930s Southampton Fourth of July Parade. (Photograph by Morris Studio; courtesy of the Shinnecock Nation Cultural Center and Museum.)

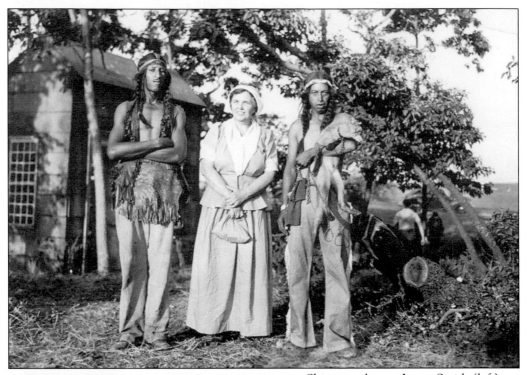

Shinnecock men James Smith (left) and Ralph "Bud" Eleazer (right) participated in a reenactment of the landing of settlers at Conscience Point in 1640. Ralph Eleazer is holding a fox, which according to tribal elders got loose that day. The woman is unidentified. (Courtesy of the Southampton Historical Society.)

These Shinnecock men are dressed up for an evening in the 1950s. They are, from left to right, Arthur T. Williams, Jimmy Hunter, James "Jake" Kellis, and James "Dutch" Smith. (Courtesy of Eugene E. Cuffee II.)

Lubin Hunter, a World War II veteran, is pictured here in his youthful 90s at a Long Island military show. He has an older brother Earl who celebrated his 100th birthday in 2015. (Photograph by Richard T. Slattery.)

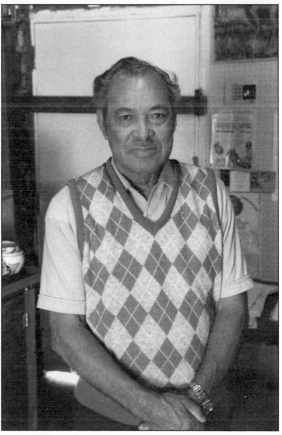

Charles Ashman, brother of Sarah, Alberta, and Arthur Ashman, is pictured here about 1988. (Courtesy of David Bunn Martine.)

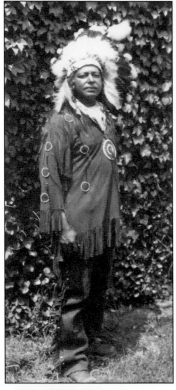

This is a photograph of Chief Elliot Kellis. (Courtesy of the Shinnecock Nation Cultural Center and Museum.)

James "Jake" Kellis was the son of Marguerite and David Kellis. He married Corrine Marshall Kellis, and they had two daughters together. (Courtesy of Eugene E. Cuffee II.)

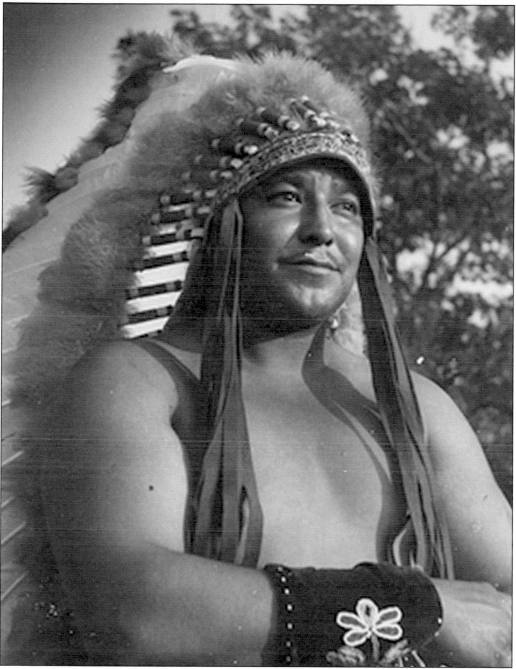

Harry K. Williams (1924–2014), also known as Chief War Hawk, was the second-longest serving elected leader since the Shinnecock trustee system of government went into effect in 1792. He was elected a trustee 27 times between 1946 and 1979. He was also known as a man of great humor, sharp wit, and insight; a lover of poetry; and was a gifted storyteller. The son of Lillian and Harry Williams, he was a sibling to Arthur T., Donald Williams Sr., Alice Franklin, Vivian Carle, and Caroline Bullock. He was married to Mary Davis and later to Rebecca Graham. (Courtesy of the Harry K. Williams family.)

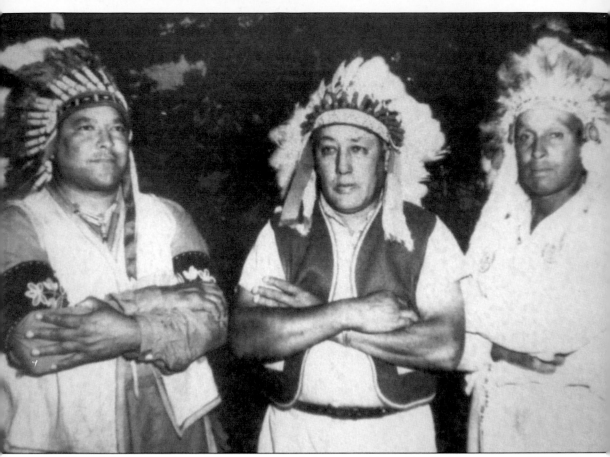

From left to right, these three men were tribal trustees (elected leaders) between the 1940s and 2000: Harry K. Williams (Chief War Hawk), Courtland Cuffee (Chief Wyandanch), and Charles K. Smith (Chief Red Fox). Charles K. Smith (Chief Red Fox) was the longest serving leader in Shinnecock history, elected for 30 consecutive years. He and his wife Bernice Dyson Smith raised six children. (Courtesy of the Shinnecock Nation Cultural Center and Museum.)

Donald Williams Sr. is cochairman of the Shinnecock Nation Council of Elders. He is the brother of Arthur T. Williams, Harry K. Williams, Caroline Bullock, Vivian Carle, and Alice Franklin. (Photograph by Beverly Jensen.)

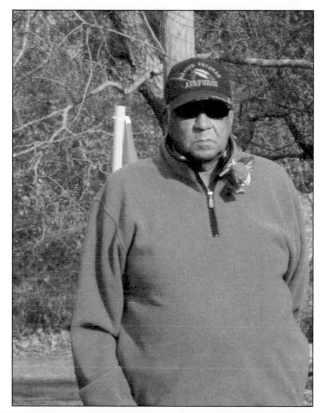

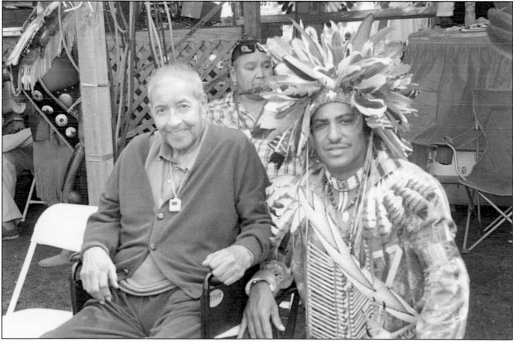

Former trustees Harry K. Williams (left) and Randy King (right) pose for a picture. They are pictured at the Shinnecock Powwow in 2011. (Photograph by Beverly Jensen.)

Arthur "Mike" Lee Crippen Jr. is pictured at his home in New Hampshire in 1990. He is the son of Alvilda and Arthur Crippen, grandson of Emmett and Harriett Ruben Lee Crippen, and the great-grandson of Everett Lee. (Courtesy of Mike Crippen.)

Ferdinand Lee was the son of Ferdinand and Esther Lee, the grandson of Everett Lee, and the great-grandson of the seafaring Ferdinand Lee. He was a mason by trade. (Photograph by Beverly Jensen.)

David Bunn Martine is an author and an artist with many of his works on display at the Shinnecock Nation Cultural Center and Museum, where he is also curator and artistic director. He is the son of Marjorie Martinez, the grandson of Osceola Bunn Martine, and the great-grandson of Charles S. Bunn. (Photograph by Beverly Jensen.)

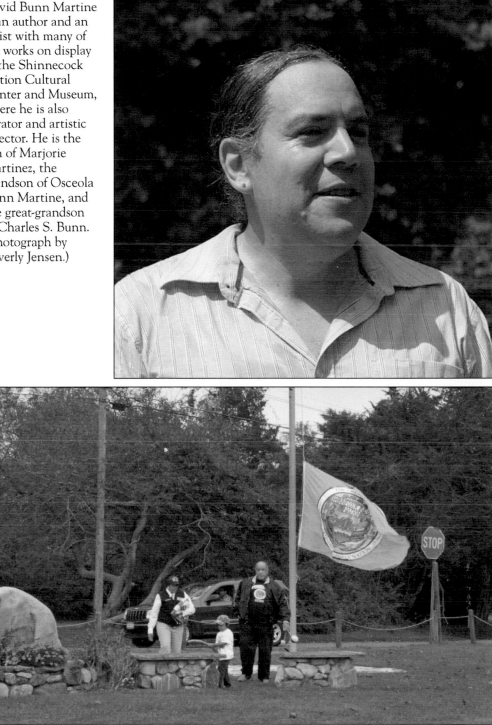

Tribal members Susan Soto and Fred Bess raise the Shinnecock flag on October 10, 2011. The date is of major significance to the tribe because it marked the first anniversary of the tribe's federal recognition. (Photograph by Beverly Jensen.)

On the 1926 Southampton High School football team, Arthur Lee Crippen Sr. (second row, far right) was a star player. He was the husband of Alvilda Crippen and father of Arthur Lee Crippen Jr., Carmen Murphy, Thom Crippen, Joan Williams, Wayne Crippen, Roma Niles, Laurie Sanders, Beverly Jensen, and Cheryl Munoz. (Courtesy of the Shinnecock Nation Cultural Center and Museum.)

1926 Football Team

Row 1 L-R Abner Bennett, George Buckheit, Chester Buttonow, Edward Whitman, Capt.: Halsey White, Carl Phillips, William Bailey.
Row 2 L-R Clayton Culver, Norman Mercer, Francis Jessup, Francis McGurn, Arthur Crippen
Row 3 L-R Albert Topping, Courtney Phillips, Arthur Smith, Robert Lippman, Clifford Aldridge, Paul Topping.
Row 4 L-R Albert Griffin, Mgr.: Edward McGuirk, Charles Schwartz. Coach: Richard Smith

Phillip Gomez (left, Taos Pueblo), was the husband of Lori Jensen Gomez (Shinnecock) and the father of Alyssa Sunbow, Alexandria Spring Water, and Elijah Storm Star Gomez. Also pictured is Andrew Hunter (Meherrin tribe of North Carolina), who was the husband of Karen Hunter (Shinnecock), who is a daughter of Arthur Lee Crippen Jr. and Shirley Jensen Crippen. (Photograph by Beverly Jensen.)

Thom Crippen was a US Army veteran. He is pictured making announcement in this 1990 Shinnecock Powwow image. (Courtesy Beverly Jensen.)

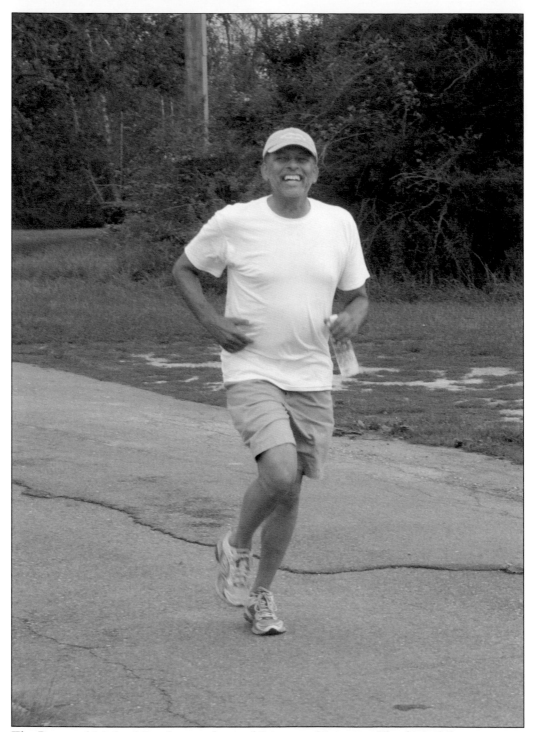

The Reverend Michael Smith, a graduate of Princeton University Theological Seminary, is a tribal member and pastor at Shinnecock Presbyterian Church. He is also executive director of the Substance Abuse Mobilization Project (SAMP). Annually, SAMP holds a 5k walk/run around the reservation, in which Reverend Smith participates. (Photograph by Beverly Jensen.)

Eight

WICKIUP TO WOOD

This house is the homestead of Camille and Tom Smith, and they raised their 10 children here. (Courtesy of Shirley Smith.)

Pictured here is the home of Helen Bunn Hendrick, which is the former home of her father, Charles Sumner Bunn. This photograph was taken in the mid-1980s. (Courtesy of the Shinnecock Nation Cultural Center and Museum.)

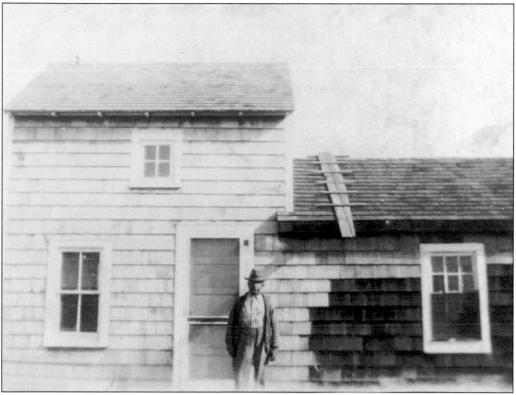

Oliver Kellis is pictured in front of his Shinnecock house. Tribal elders today remember Oliver Kellis as owning horses and buggies and giving them rides into town. (Courtesy of the Shinnecock Nation Cultural Center and Museum.)

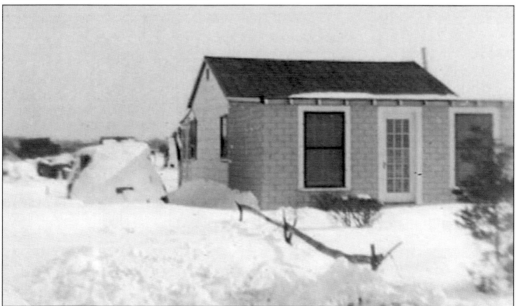

The homestead pictured is the home of Frances and Catherine Bosley. (Courtesy of Lucille Bosley.)

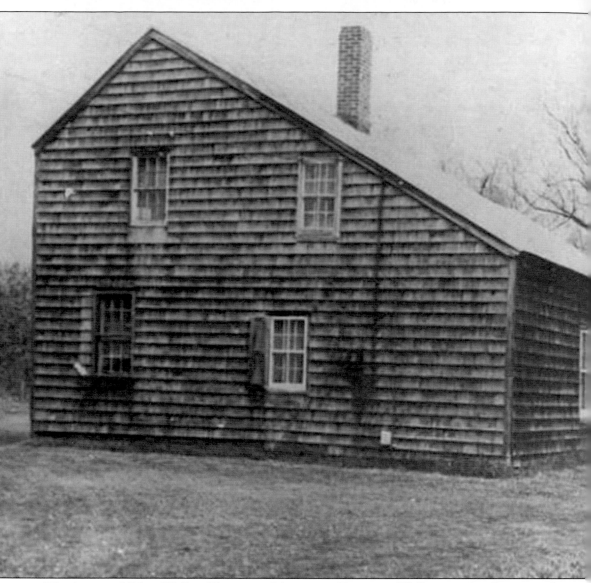

The house of Edna Walker Eleazer and her sister Ernestine Walker on the Shinnecock Reservation was in the English Saltbox style. (Courtesy of the Shinnecock Nation Cultural Center and Museum.)

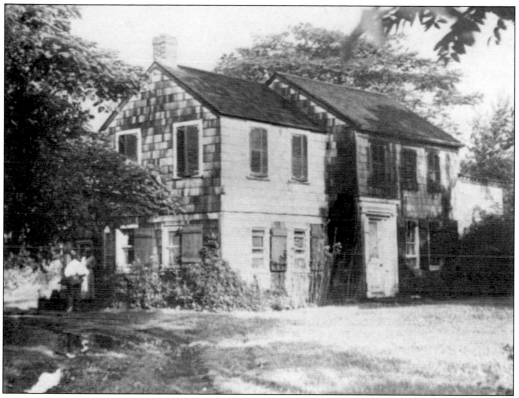

Mary Rebecca Bunn Lee's house, built in 1884, was the Winfield Lee homestead. It was located across the street on West Gate Road from the Shinnecock Presbyterian Church and stood through the 1960s. It no longer exists. (Courtesy of the Shinnecock Nation Cultural Center and Museum.)

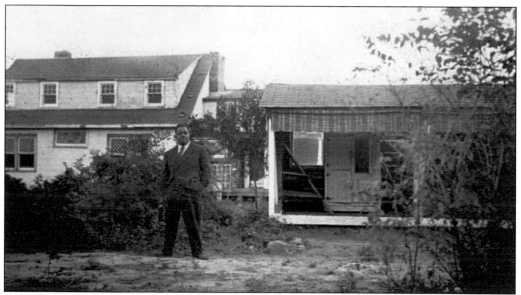

Helen Bunn's vegetable stand was on the reservation in front of her house on Montauk Highway. (Courtesy of the Shinnecock Nation Cultural Center and Museum.)

The Shinnecock Tribal Family Preservation building is utilized by a number of groups, including the Shinnecock Education and the Shinnecock Seniors, as well as Shinnecock Cultural Enrichment Programs. (Photograph by Beverly Jensen.)

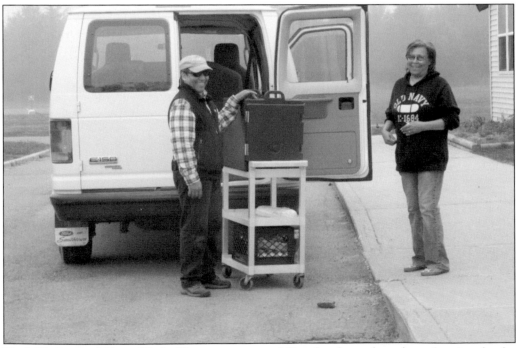

Keith Phillips and Eloise Weeks Eleazer prepare to deliver lunches to homebound seniors for the Shinnecock Senior Nutrition Program. (Photograph by Beverly Jensen.)

Nine

GATHERINGS

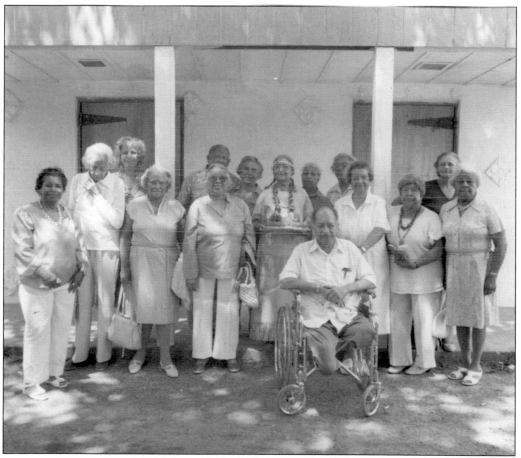

A group of 15 elders at the Shinnecock Community Center celebrate the establishment of their senior program, which was directed by Shirley Smith. (Courtesy of Shirley Smith and the Toba Tucker Collection at the Yale University Beineke Library.)

A group of elders pose outside the Shinnecock Community Center. They are, from left to right, Warren Eleazer, Pauline Kirby, Garland Gill (friend, meaning not a tribe member), and Libby Goodall. (Courtesy of the Shinnecock Nation Cultural Center and Museum and the Toba Tucker Collection at the Yale University Beineke Library.)

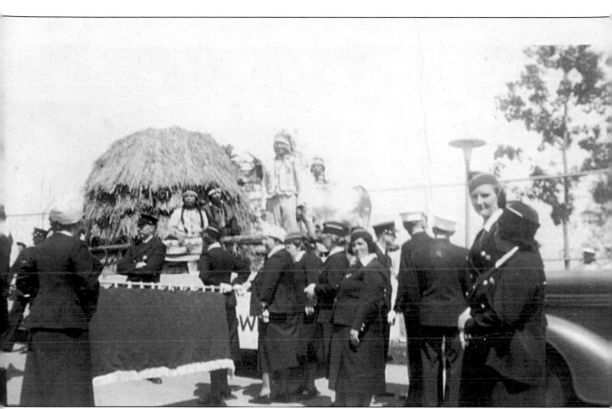

Tribal members attended the world's fair in New York City in 1939. They are on a parade float with a wickiup and dressed in full regalia, traditional Shinnecock clothing. (Courtesy Shinnecock Nation Cultural Center and Museum.)

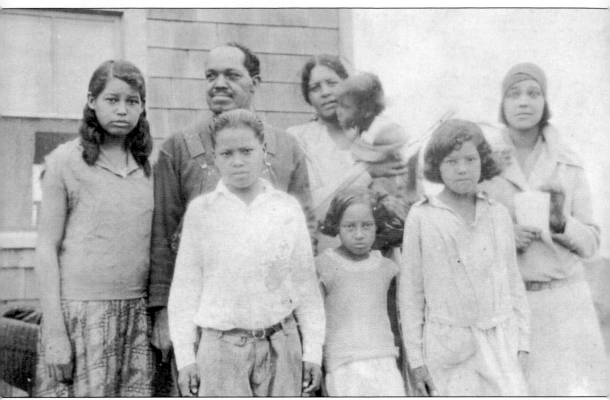

The family of Marguerite and David Kellis gather for this picture taken in the 1930s. They are, from left to right, (first row) James, Pearl, and Eva; (second row) Blanche, David, Marguerite, Winnie, and Elsie. (Courtesy of Eugene E. Cuffee II.)

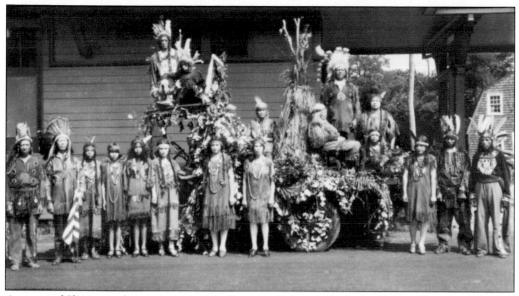

A group of Shinnecocks participates in a Fourth of July parade in the 1930s. They posed for this photograph at the Southampton Railroad Station before the parade began. (Photograph by Morris Studio; courtesy of the Shinnecock Nation Cultural Center and Museum.)

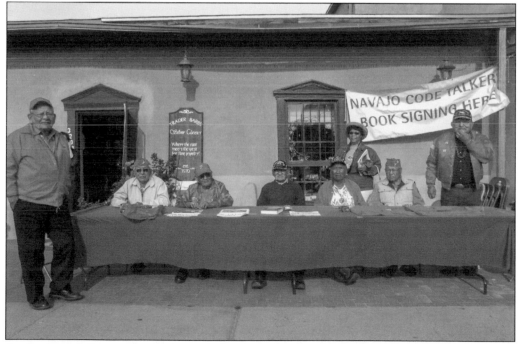

Author Beverly Jensen (beside the sign), daughter of Arthur Lee Crippen Sr. and Alvilda Crippen, is with Navajo code talkers in Albuquerque, New Mexico, for the Gathering of Nations Powwow in April 2008. (Photograph by Richard T. Slattery.)

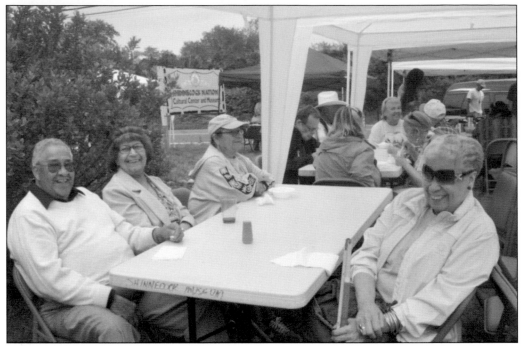

Tribal elders meet at a Shinnecock Nation Cultural Center and Museum event. Seen here are, from left to right, Arthur T. Williams, Shirley Smith, Eleanor Franklin, and Joyce Franklin. (Photograph by Beverly Jensen.)

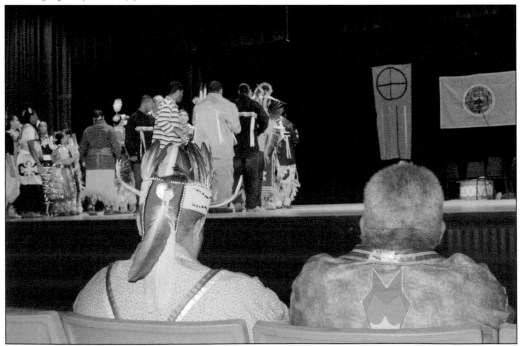

Tribal leaders Daniel Collins Sr. (left) and Brad Smith (right) support Shinnecock youth in a performance at Southampton High School on Native American Day in 2013. (Photograph by Beverly Jensen.)

Ten

POWWOWS

Marjorie Martinez and her father, Charles Martinez, are pictured at a 1930s gathering. (Courtesy of David Bunn Martine.)

White Eagle (left) and Swift Eagle (right) are pictured at a 1940s Shinnecock Powwow. Swift Eagle was from the Santo Domingo tribe of New Mexico. (Courtesy of the Shinnecock Nation Cultural Center and Museum.)

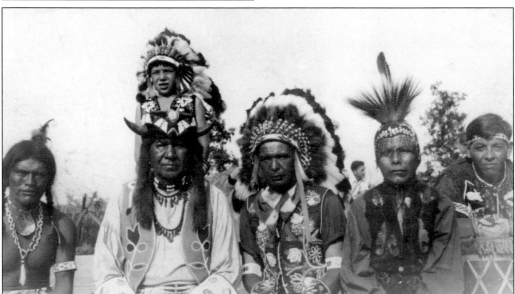

Swift Eagle (far left) is pictured at a 1940s Shinnecock Powwow. He performed many dances and was particularly known for his rendition of the Eagle Dance. (Courtesy of the Shinnecock Nation Cultural Center and Museum.)

This picture of Swift Eagle is from the 1960s. He was also known for his rendition of the Horse Dance. (Courtesy of the Shinnecock Nation Cultural Center and Museum.)

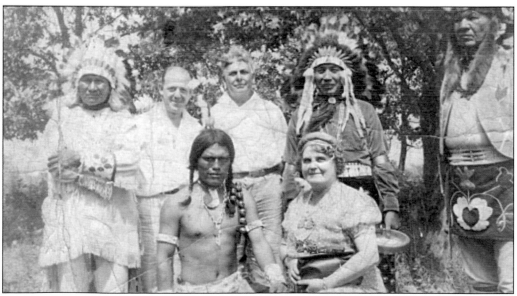

Swift Eagle posed with visitors and chiefs at a 1950s Shinnecock Powwow. He attended the annual event for several decades with his entire family, including his wife and children. (Courtesy of the Shinnecock Nation Cultural Center and Museum.)

Powwow dignitaries are on stage at the Shinnecock Powwow in the 1960s. (Courtesy of the Shinnecock Nation Cultural Center and Museum.)

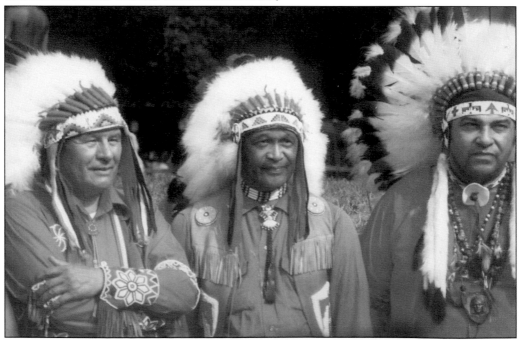

Ceremonial chiefs of the 1960s at the Shinnecock Powwow are picture here. They are, from left to right, Bright Canoe (Mohawk), Thunder Bird (Shinnecock), and Strong Horse (Narragansett). (Courtesy of the Shinnecock Nation Cultural Center and Museum.)

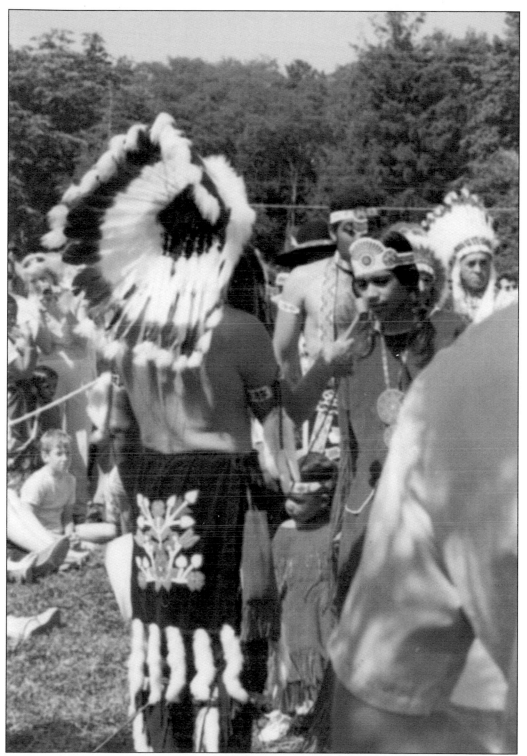

Powwow participants are dressed in traditional regalia at a 1967 powwow at Shinnecock. (Courtesy of the Shinnecock Nation Cultural Center and Museum.)

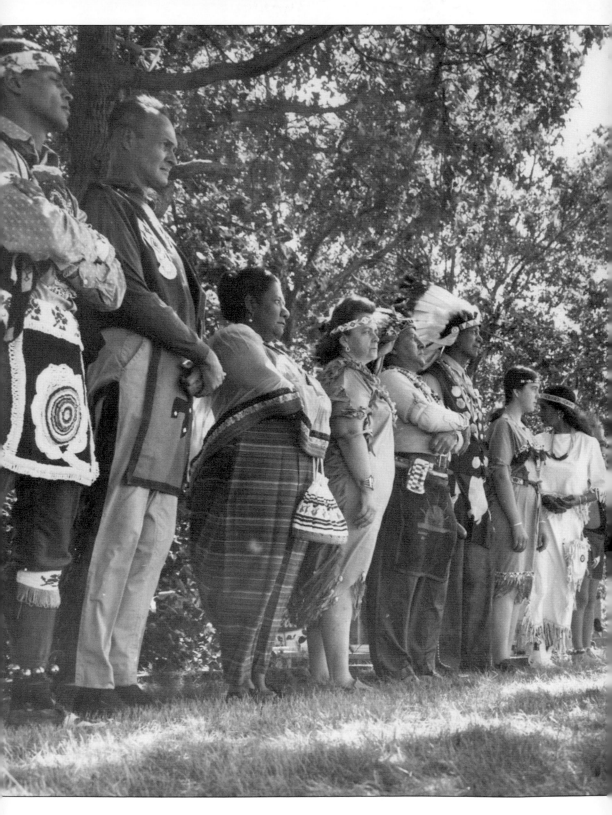

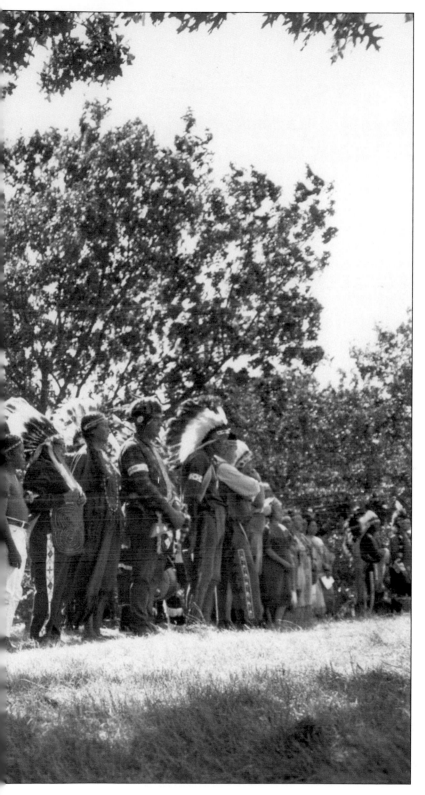

Participants line up at a 1967 Shinnecock Powwow in preparation for a Welcome Dance. (Courtesy of the Shinnecock Nation Cultural Center and Museum.)

Announcing . . . The Annual

Shinnecock Indian POWWOW

ON LABOR DAY WEEK-END
September 2, 3, 4, 1967

2:00 p.m. Each Day — 9:00 p.m. Saturday and Sunday

On the Historic SHINNECOCK INDIAN RESERVATION
Near SOUTHAMPTON, LONG ISLAND

Colorful Costumes — Authentic Songs and Dances
by INDIANS from the EAST and FAR WEST

FREE PARKING ADMISSION — Adults $1.00, Children 50c

A 1967 Shinnecock Powwow ticket shows how prices have changed. In 2014, the price of admission was $15 for adults. (Courtesy Shinnecock Nation Cultural Center and Museum.)

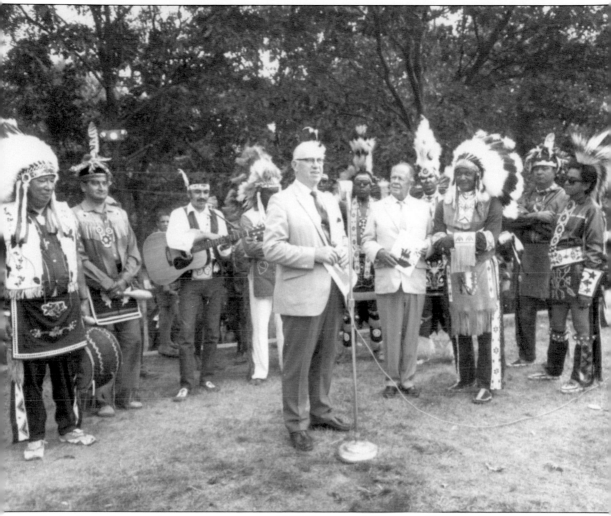

Dignitaries and entertainers are on stage at a 1969 Shinnecock Powwow. (Courtesy Shinnecock Nation Cultural Center and Museum.)

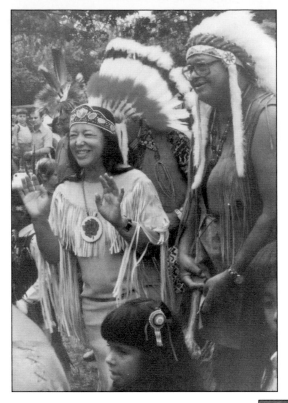

Elizabeth Haile, also known as Chee Chee, of Shinnecock and Ferris Dove of the Narragansett Nation participates in a 1970s Shinnecock Powwow Grand Entry. (Photograph by Beverly Jensen.)

In the Grand Entry of a Shinnecock Powwow of the 1970s, Shinnecock youngsters follow Rosemary Richmond (Mohawk) in line to the dance arena. (Photograph by Beverly Jensen.)

114

Shinnecock men James Eleazer Jr. (left) and Wayne Red Dawn Crippen (right) chat in front of a vendor stand at a 1970s Shinnecock Powwow. (Courtesy of Wayne Red Dawn Crippen.)

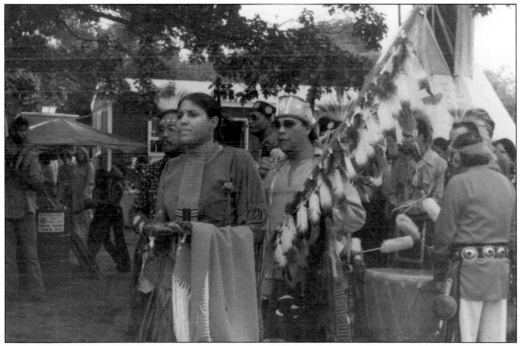

At a 1970s Shinnecock Powwow, Shinnecock tribal members Josephine Smith (front), Eugene Cuffee (left), and Wayne Red Dawn Crippen (right) marched in Grand Entry. (Photograph by Beverly Jensen.)

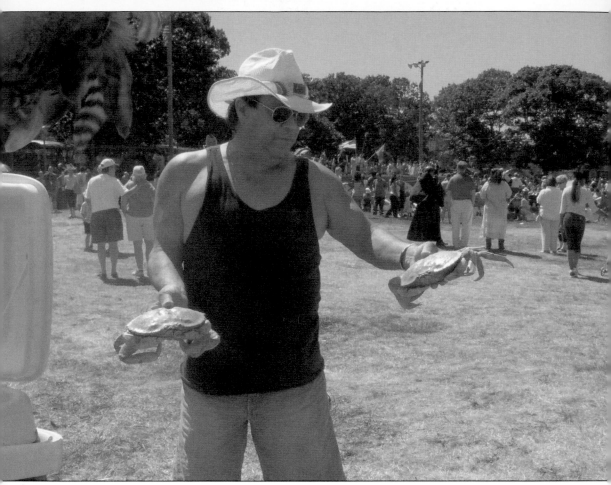

Wayne Red Dawn Crippen is pictured with cooked crabs at a Shinnecock Powwow. (Photograph by Beverly Jensen.)

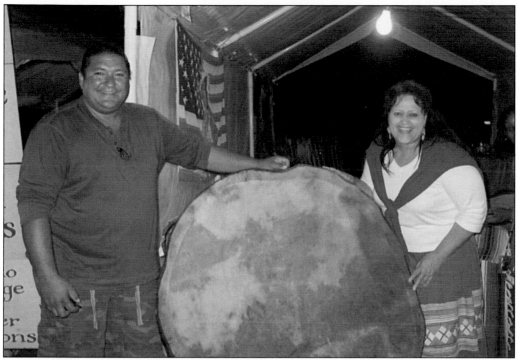

In this 2008 image, drum maker Phillip Gomez (Taos Pueblo) and Holly Haile (Shinnecock) pose for a photograph. (Photograph by Beverly Jensen.)

A very large drum made by Phillip Gomez was on display at the Shinnecock Powwow in 1968. (Photograph by Beverly Jensen.)

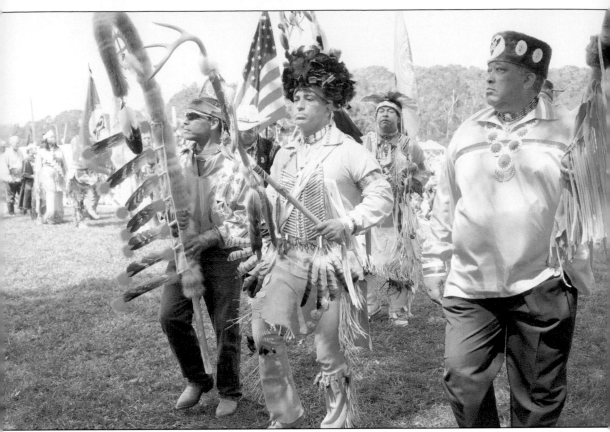

The 2011 Shinnecock trustees lead the Grand Entry in 2011. They are, in the foreground from left to right, Gerrod Smith, Randy King, and Fred Bess. Former trustee Lance Gumbs follows the three. (Photograph by Beverly Jensen.)

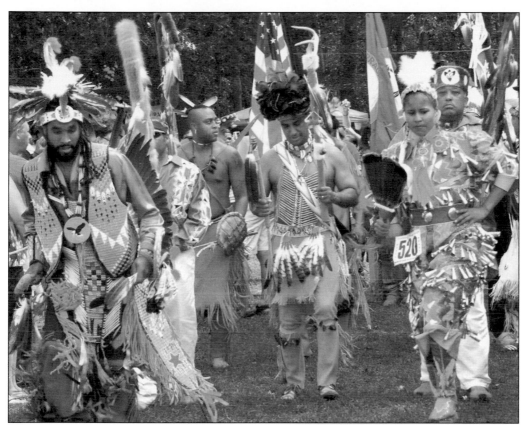

This photograph was taken during the 2011 Shinnecock Powwow Grand Entry with lead dancers Andrew Cuffee (left) and Sunshine Gumbs (right). From left to right behind them are tribal member John Boyd (behind Cuffee), former trustee chairman Randy King, and former trustee Fred Bess (behind Gumbs). (Photograph by Beverly Jensen.)

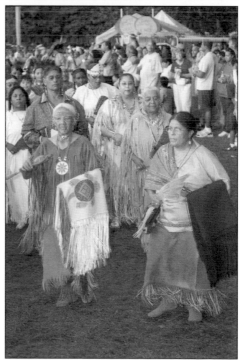

Winonah Warren (right) of Shinnecock leads traditional women in the 2011 Shinnecock Powwow Grand Entry. (Photograph by Richard T. Slattery.)

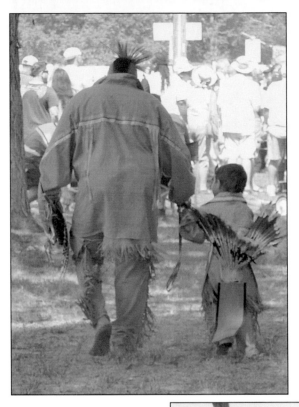

Powwow culture is being passed down between father and son at the 2013 Shinnecock Powwow. (Photograph by Beverly Jensen.)

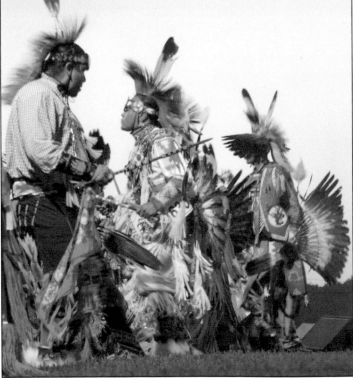

Male dancers perform at the 2013 Shinnecock Powwow. (Photograph by Beverly Jensen.)

Avery Dennis Sr., one of the tribe's longest serving trustees, poses with his wife, Dorothy Dennis Tribal, at the 2013 Shinnecock Powwow. (Photograph by Beverly Jensen.)

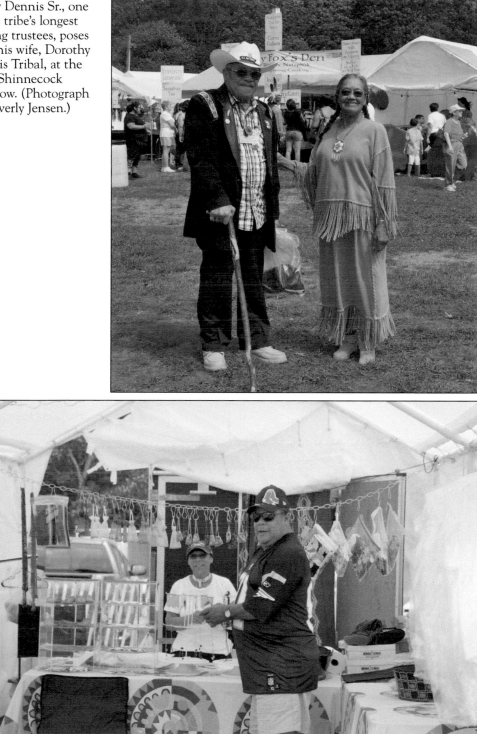

Powwow vendor Joan Williams chats with her brother Wayne Crippen at the Shinnecock Powwow in 2013. (Photograph by Beverly Jensen.)

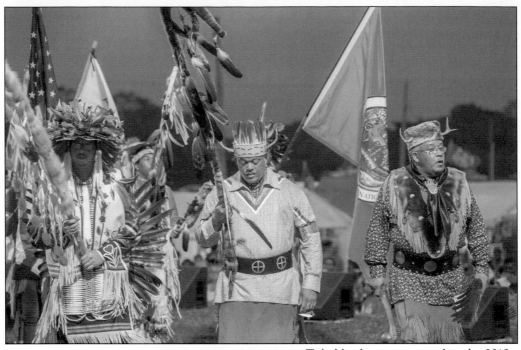

Tribal leaders are pictured in the 2013 Shinnecock Powwow Grand Entry. They are, from left to right, trustees Taobi Silva, Daniel C. Collins, and Eugene E. Cuffee II. Trustee Cuffee is also the tribe's official sachem. (Photograph Richard T. Slattery.)

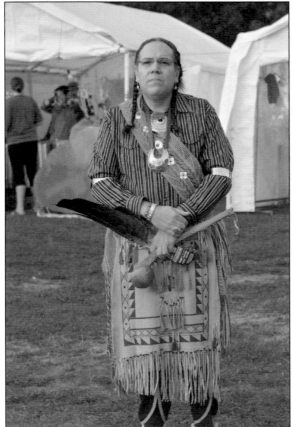

David Bunn Martine, curator of the Shinnecock Nation Cultural Center and Museum, is dressed in traditional regalia at the 2013 Shinnecock Powwow. (Photograph by Beverly Jensen.)

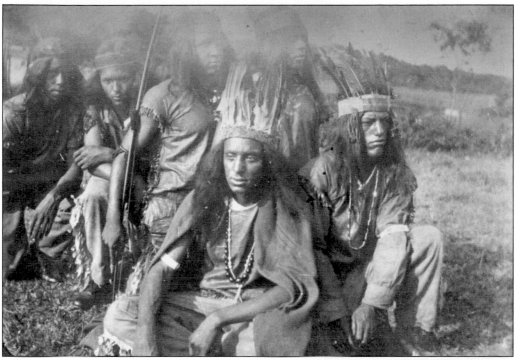

Depicted here is a group of Shinnecock men dressed in native attire (regalia) for a 1930s celebration. (Courtesy of Eugene E. Cuffee II.)

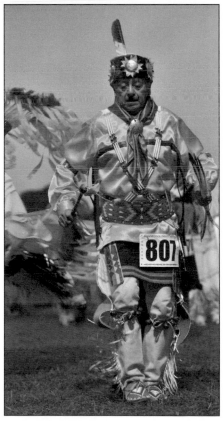

Louie Mofsie, also known as Green Rainbow, a Hopi/Winnebago, has attended every Shinnecock Powwow for over three decades. He has also performed in every one, first as a hoop dancer and later as part of the Thunderbird American Indian Dancers as a singer and drummer. (Photograph by Richard T. Slattery.)

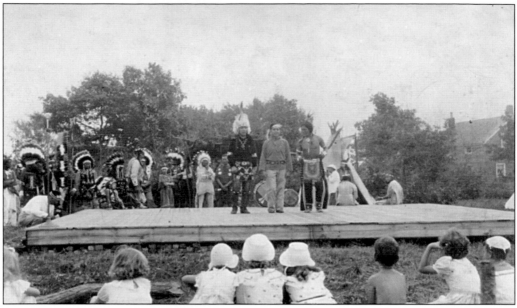

Before the annual Labor Day powwow was established, Shinnecock people held powwows and pageants at different times and in different areas around the reservation and in town. This one took place on the reservation at the Thompson family property in the 1930s or 1940s. By 2015, the Shinnecock were celebrating the 69th annual powwow. (Courtesy of the Shinnecock Nation Cultural Center and Museum.)

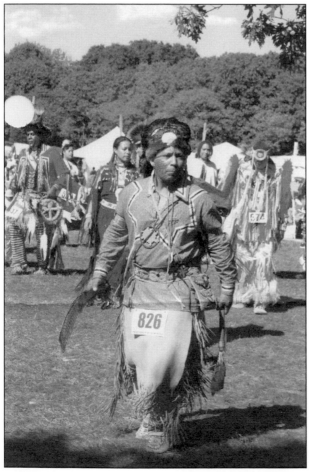

Keith Phillips, a US Navy veteran, is a Shinnecock traditional dancer. He has won many powwow dance competitions in men's traditional and men's eastern war dance categories. (Courtesy of James and Marion Phillips.)

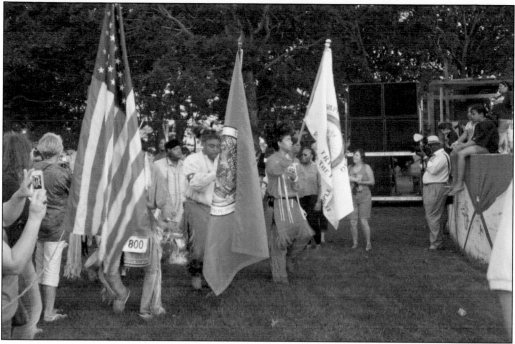

It is a show of deep respect for sovereign flags to be carried in Native American gatherings, such as powwows. In addition to the American flag, this photograph shows the flags of the Shinnecock Indian Nation and the Mashpee Wampanoag tribe of Massachusetts being carried in Grand Entry at a Shinnecock powwow. (Photograph by Beverly Jensen.)

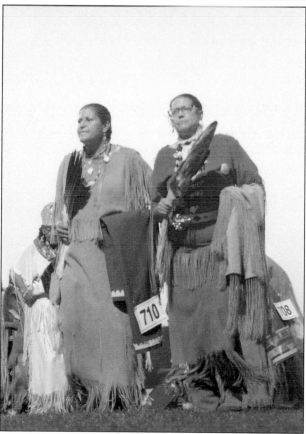

Sisters Josephine Smith (left) and Dr. Eva Chase (right) are pictured in the Grand Entry at a Shinnecock Powwow. Josephine Smith helps preserve Shinnecock culture through the cultural enrichment programs, while Dr. Chase helps preserve health. (Photograph by Beverly Jensen.)

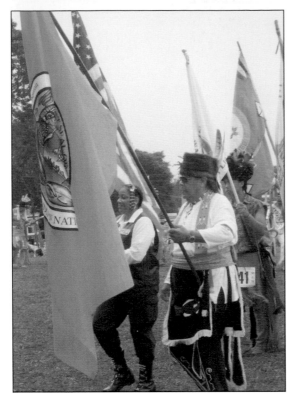

Flags of the United States and the Shinnecock Indian Nation are carried by military veterans Susan Soto (US Air Force) and Wayne Red Dawn Crippen (US Army). (Photograph by Beverly Jensen.)

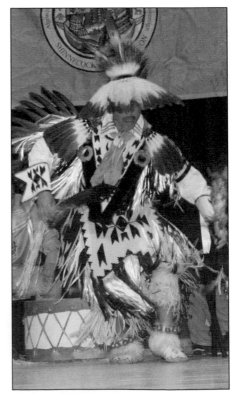

Former trustee Charles K. Smith II performs at Southampton High School on Native Day. He is the son of the tribe's longest serving trustee, Charles K. Smith I. (Photograph by Beverly Jensen.)

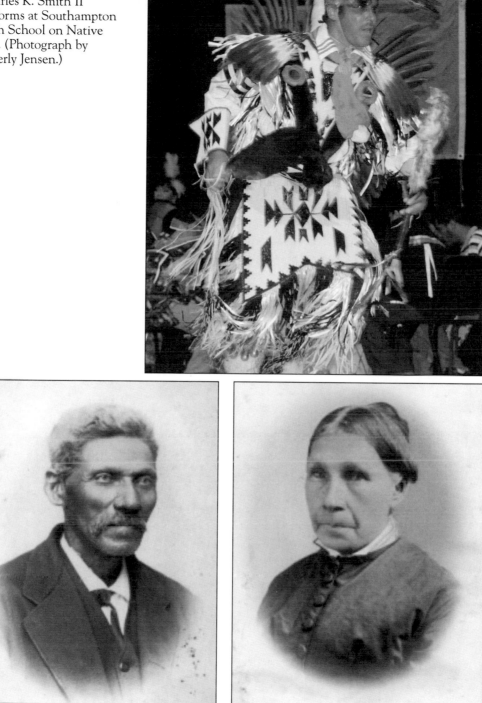

Charles K. Smith II performs at Southampton High School on Native Day. (Photograph by Beverly Jensen.)

James Bunn is shown with his wife, Sophia Waukus Bunn, parents of Adeline Bunn Waters (1844–1913) and Anna Bunn Kellis (1845–1939), here representing continuity and history. *Mamoweenene (We move together)*. (Both, courtesy of the Shinnecock Nation Cultural Center and Museum.)

DISCOVER THOUSANDS OF LOCAL HISTORY BOOKS FEATURING MILLIONS OF VINTAGE IMAGES

Arcadia Publishing, the leading local history publisher in the United States, is committed to making history accessible and meaningful through publishing books that celebrate and preserve the heritage of America's people and places.

Find more books like this at
www.arcadiapublishing.com

Search for your hometown history, your old stomping grounds, and even your favorite sports team.